HANGJIA
DAINIXUAN

行家带你选

串 珠

姚江波 ／ 著

中国林业出版社

图书在版编目 (CIP) 数据

串珠 / 姚江波著 . – 北京：中国林业出版社，2019.1
（行家带你选）
ISBN 978-7-5038-9884-6

I. ①串… II. ①姚… III. ①手工艺品 – 鉴定 – 中国
IV. ① TS973.52

中国版本图书馆 CIP 数据核字 (2018) 第 277121 号

策划编辑　徐小英
责任编辑　梁翔云　徐小英
美术编辑　赵　芳　刘媚娜

出　　版　中国林业出版社(100009 北京西城区刘海胡同7号）
　　　　　http://lycb.forestry.gov.cn
　　　　　E-mail:forestbook@163.com　电话：(010)83143515
发　　行　中国林业出版社
设计制作　北京捷艺轩彩印制版技术有限公司
印　　刷　北京中科印刷有限公司
版　　次　2019 年 1 月第 1 版
印　　次　2019 年 1 月第 1 次
开　　本　185mm×245mm
字　　数　186 千字（插图约 390 幅）
印　　张　11
定　　价　70.00 元

孔雀石手串

茶晶串珠

唐三彩单珠与西周和田玉镯（三维复原色彩图）

绿松石串饰·新石器时代

◎ 前 言

　　串珠是人类社会发展的必然产物，人类对于美的追求是永恒的，而串珠就是这一过程中的重要体现。如玉串饰早在新石器时代就有，有骨角、贝蚌的串饰，同样也有绿松石的串饰……，串联方式也是多种多样。但规格高、串联较为复杂的大型串饰应该是在西周晚期才出现，时代为西周晚期至春秋早期的大型邦国公墓虢国墓地出土的大型玉组佩，应为目前发现的串联最为复杂的串饰。组合玉佩由数百件（颗）的玛瑙珠、玉管、玉璜、料珠组成，展开长度可达上百厘米，挂于颈部达于膝下，这是何等宏大的构思。但是，这种过于奢侈的玉组佩在礼制崩溃后，逐渐走了下坡路，虽然在春秋战国时期组合玉佩也有发展，但从各方面看都无法与礼器时代的大型玉组佩相提并论。值得庆幸的是，在大型玉组佩衰落之后，以装饰实用为主的串珠大量出现，手串、念珠、朝珠、项链、圆珠、方珠、算珠、筒珠、异形珠等。秦汉以降，直至明清，当代人们更是对其趋之若鹜。而且，这一趋势继续发展，人类对大型玉组佩剩下的只是记忆。串珠在漫长的历史长河中材质也是不断地增加，在诸多方面都有了相当程度的超越。当今，是以往任何一个时代都不能比拟的，材质已经由早期的铜贝、石蚌、骨陶、金银等，延伸至珊瑚、猫眼、碧玺、托帕石、橄榄石、海蓝宝石、祖母绿、磷铝锂石、锂辉石、矽线石、翡翠、和田玉、白欧泊、黑欧泊、火欧泊、寿山石、田黄、青田石、水镁石、苏纪石、异极矿、锂云母、玉髓、玛瑙、黄龙玉、蓝玉髓、绿玉髓（澳玉）、木变石、虎睛石、鹰眼石、石英岩、水钙铝榴石、硅硼钙石、羟硅硼钙石、方钠石、赤铁矿、天然玻璃、黑曜岩、玻璃陨石、鸡血

玛瑙珠、组合玉佩·西周

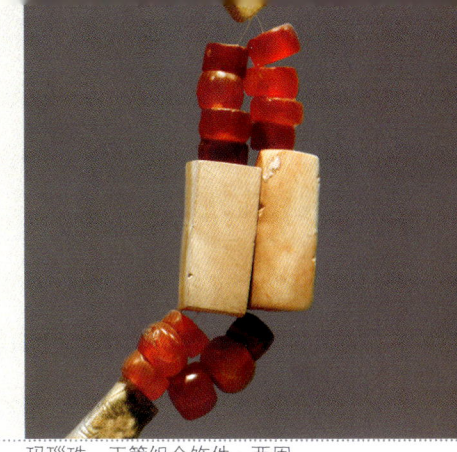

玛瑙珠、玉管组合饰件·西周

石、针钠钙石、绿泥石、东陵石、岫玉、独山玉、查罗石、钠长石玉、蔷薇辉石、阳起石、绿松石、青金石、孔雀石、硅孔雀石、葡萄石、大理石、汉白玉、白云石、蓝田玉、菱锌矿、菱锰矿、萤石、珍珠、蜜蜡、血珀、金珀、绿珀、蓝珀、虫珀、植物珀、煤精、象牙、玳瑁、砗磲、硅化木等，由此可见，种类丰富之极，犹如灿烂星河，璀璨夺目。当代，串珠以前所未有的速度在发展。但也有相当多的古串珠材质没有大规模地流行，或者流行时间比较短，只是"昙花一现"，很快就消失了。只有少数质地的串珠能够长盛不衰，如珊瑚、琥珀、玛瑙、绿松石、玉串珠等，流行之广，几乎贯穿了整个中国古代史，成为上至帝王将相，下至老百姓在市井之上主要把玩的艺术品。

　　中国古代串珠虽然离我们远去，但人们对它的记忆是深刻的，这一点反映在收藏市场之上。在收藏市场上，历代串珠都受到了人们的热捧，各种古串珠在市场上都有交易，且有很多创造的都是天价。当代串珠也不让古代，以质为重，优质的串珠也是不断创造着价格神话。如和田玉青海料串珠在几十年间升值近百倍，沉香、南红、珊瑚串珠等也都是资本升值的明星。但在暴利的驱使下，也注定了各种各样作伪的古串珠频出，成为市场上的鸡肋。高仿品与低仿品同在，鱼龙混杂，真伪难辨，串珠的鉴定成为一大难题。而本书从文物及当代艺术品鉴定角度出发，力求将错综复杂的问题简单化，以质地、造型、厚薄、风格、纹饰、打磨等鉴定要素为切入点，具体而细微地指导收藏爱好者由一串串珠的细部去鉴别串珠之真假，评估古串珠之价值，力求做到使藏友读后由外行变为内行，真正领悟收藏，从收藏中受益。以上是本书所要坚持的初衷，但一种信念再强烈，也不免会有缺陷，希望不妥之处，大家给予无私的指正和帮助。

<div align="right">

姚江波

2018 年 12 月

</div>

◎ 目 录

青金石串珠

虎睛石串珠

战国红玛瑙算珠

第一章　串珠质地

第一节　常见串珠

1. 和田玉串珠。和田玉可以分为白玉、糖玉、青白玉、青玉、黄玉、碧玉、墨玉等。和田白玉的矿物组成主要是透闪石、阳起石，是一种天然玉石，微透明。和田玉的概念有狭义和广义两种观点：狭义和田玉概念比较具体，就是新疆和田玉。广义和田玉认为只要是透闪石玉都是和田玉，在硬度、密度、折

玉组佩饰·西周

射率等达到标准的情况，都可以称之为和田玉。这样，青海料、俄罗斯料、韩国料、加拿大料、贵州料、四川料、辽宁料、台湾料等都可以成为和田玉。从造型上看，和田玉串珠相当盛行，造型众多，如项链、手串、脚链、吊坠、佛珠、多宝串、车挂串等都有见，特别是以手串、吊坠、项链等为多见，其中又以手链最为常见。珠子的造型以圆球体为主，其他各种造型也都有见，大小不一，也有以小的籽料原石打孔组成的串珠，也是相当的漂亮，精美绝伦。从数量上看，和

优化新疆和田玉新疆籽料串珠料

田玉串珠在数量上有相当的量，十分常见，市场上琳琅满目，到处都是，在总量上所占和田玉的比例很大。从时代上看，和田玉串珠在时代特征上并不明晰，无论是古代还是现代都比较流行。如果仅仅从数量上看，则以当代最为常见。从产地上看，一般情况下新疆和田矿产的和田玉串珠视为真玉串珠，但近年来也发现有相互混淆的情况，目的是冒充新疆料卖个高价钱，鉴定时应注意分辨。

和田青玉手串

和田青玉手串

和田青玉手串

2. 核桃串珠。这里所说的核桃并不是我们吃的核桃，而是指品种不一的野生核桃。其大小不一，品质不同，分类众多，这些核桃具有坚硬的外壳，沟壑纵横的浮雕式的纹理，使人看后心旷神怡，非常的美丽。核桃串珠很常见，目前市场上也很流行，鉴定时应注意分辨。

3. 崖柏串珠。崖柏串珠市场上有见，但数量比较少，特别是在总量上几乎是很少的，大量的都是一些侧柏，与崖柏实际上是两回事，鉴定时应注意分辨。从造型上看，崖柏串珠以手串、佛珠等为多见。从时代上看，崖柏串珠主要以当代为主，历史上很少见。

4. 翡翠串珠。翡翠的矿物组成主要是硬玉、钠铬辉石、绿辉石，是一种天然玉石。翡翠颜色以绿色为基调的各种色彩，黄色、墨色等都有见，透明到不透明，具油脂光泽，参差状断口，化学成分为硅酸盐铝钠，主要是二氧化硅、氧化钠、氧化钙、氧化镁、三氧化二铁，并含有微量的氧化铬、镍等。硬玉岩型翡翠和绿辉石岩型翡翠中多见宝石级别翡翠。世界上很多地方都产翡翠，但宝石级的翡翠基本上产地以缅甸为主。从数量上看，翡翠串珠在数量上相当丰富，在市场上琳琅满目，在总量上相当庞大，但是主要以普通的翡翠串珠为多见，真正好的翡翠串珠也是较为罕见。从造型上看，翡翠串珠在造型上比较丰富，项链、手串、脚链、吊坠、佛珠、多宝串、车挂串等都有见，可谓是集各种串珠之大成。从时代上看，翡翠串珠清代就有见，民国时期也很流行，但从数量上看显然是以当代为最。由此可见，串珠是翡翠当中最重要的造型之一。

4

翡翠串珠

翡翠串珠

翡翠串珠

翡翠手串

翡翠手串

象牙管·清代

东陵石标本

5. 象牙串珠。象牙是一种天然有机宝石，象牙的色彩为白色、乳白色等，不透明，光泽淡雅、柔和。从造型上看，象牙串珠主要以手串、项链、吊坠链、脚链等为显著特征。从数量上看，象牙串珠常见，在总量上有一定的量。从时代上看，象牙串珠主要以当代为主，古代象牙制品有见，但串珠的造型比较少见，鉴定时应注意分辨。

6. 东陵石串珠。东陵石的矿物组成主要是石英，是一种天然玉石，贝壳状断口，透明到微透明，致密、颗粒较细。从造型上看，东陵石串珠比较复杂，除了传统的手串、项链、吊坠链等之外，还有用碎石等组成的串珠，但也是非常的漂亮。从数量上看，东陵石串珠数量相当丰富，市场上到处都有见，是市场上串珠的主流材质之一。从时代上看，东陵石串珠古代也有见，但主要是以当代为主。

7. 水晶串珠。水晶的矿物名称是石英，是一种天然宝石，半透明到不透明者都有见，主要成分是二氧化硅。当二氧化硅纯度接近100%时呈现出无色透明晶体，如果里面含有其他矿物，呈现出不同的色彩，如紫

茶晶串珠

茶晶串珠

芙蓉石手串

色、黑色、粉色、黄色、茶色、绿色、棕色等，断口平坦状。用水晶制作串珠是水晶造型的主要方面。手串、脚链、项链、佛珠、挂件等各种各样的串珠都有见，但白色或者是无色水晶制作而成的水晶串珠并不是主流，而主要以有色水晶串珠为显著特征的。如芙蓉石、黄晶、紫晶、茶晶、墨晶、红色水晶串珠等。鉴定时应注意分辨。

芙蓉石手串

8. 田黄串珠。田黄的矿物组成主要是迪开石、高岭石、珍珠陶土，是一种天然玉石，色如蜂蜜，淡雅、柔和。从造型上看，田黄串珠主要以手串为多见，圆球形珠为主，串联方式较为简单。从数量上看，田黄串珠比较少见，特别是质优者更是少见。从时代上看，田黄串珠以当代为主，古代不是很常见。鉴定时应注意分辨。

9. 青田石串珠。青田石的矿物组成主要是叶蜡石、迪开石、高岭石，是一种天然玉石，红、白、黄、黑等都有见，微透明。从数量上看，青田石串珠有见，但数量不是太多。从造型上看，青田石串珠以手串、项链等为多见，串联组合方式并不复杂。从时代上看，青田石串珠主要以当代为主，古代很少见。

10. 红酸枝串珠。红酸枝市场上有见，而且是大量有见，只是在品级上有高低之分，当然价格也是相差甚远。总之，在总量上相当庞大。从造型上看，红酸枝串珠以串珠、佛珠、项链等为显著特征。从时代上看，红酸枝串珠在时代上以当代最为常见，历史上也有见，但数量与当代不可同日而语。鉴定时应注意分辨。

酸枝手串

酸枝手串

酸枝手串

11. 蓝田玉串珠。蓝田玉的矿物组成主要是蛇纹石化大理石，是一种天然玉石，米黄色、浅绿至绿色等，渐变性比较强，微透明。从造型上看，蓝田玉串珠主要以手串、项链、吊坠链等为显著特征。从数量上看，蓝田玉串珠市面上并不是很常见，可以说只是偶见。从时代上看，蓝田玉串珠在遥远的古代就有见，当代也有见，可见无论是古代还是当代都非常流行。

12. 鸡血石串珠。鸡血石的矿物组成主要是辰砂、迪开石、高岭石、叶蜡石、明矾石，"血"是辰砂，"地"是迪开石、高岭石、叶蜡石、明矾石等，是一种天然玉石，血色浓深，深入胎骨。从数量上看，鸡血石串珠比较常见，各种各样的鸡血石串珠市场上都有见，在总量上有一定的量。从造型上看，鸡血石串珠造型以手串、项链等为常见，组合方式比较简单。从时代上看，鸡血石串珠以当代为主，古代少见。

酸枝念珠

酸枝手串

13. 黄花梨串珠。黄花梨串珠市场上有见，品质相差很大，价格天壤之别，在总量上有一定的量。从造型上看，黄花梨以手串、佛珠、手链为多见，造型隽永，非常漂亮，深受人们喜爱。从时代上看，黄花梨串珠时代特征比较复杂，古代有见，如清代念珠等就比较流行，当代更加流行。

14. 黄龙玉串珠。黄龙玉（黄玉髓）的矿物组成主要是石英，是一种天然玉石，微透明到透明。不同矿物的含量决定黄龙玉色彩的差异，如黄色、红色、白色、黑色、灰色等，纯色及融合色彩共生。极为稀少伴随有水晶、玛瑙、玉髓、碧玉等。光性特征为隐晶质集合体。从造型上看，黄龙玉串珠主要以手串、项链、佛珠等为显著特征，其中以手链最为常见，也有一些加入现代元素如车挂等，在造型上并不复杂。从数量上看，黄龙玉串珠在数量上比较庞大，在总量上有相当的量。其品级等级森严，高品级的黄龙玉手串数量相当少见。从时代上看，黄龙玉串珠以当代为主，古代很少见，因为黄龙玉是2010年才登上国家宝玉石名录（GB/T16552—2010）成为天然玉石一种的，因此黄龙玉串珠的年代特征就是当代的数十年间。

15. 汉白玉串珠。汉白玉的矿物组成主要是方解石，是一种天然玉石，灰白色，在色彩上有一定偏色等，微透明到不透明，光泽柔和。从数量上看，汉白玉串珠市场上随处可见，各种色彩的汉白玉被制作成珠子，用于制作各种串珠。从造型上看，汉白玉串珠在造型上以手串、脚链、项链，以及吊坠链为显著特征。从时代上看，汉白玉串珠主要以当代为主，其他时代有见，但数量并不是很多，显然还没有形成一定规模。

黄花梨串珠

黄花梨串珠

黄花梨串珠

黄花梨串珠

黄花梨串珠

16. 小叶紫檀串珠。印度小叶紫檀串珠市场上常见，从数量上看，有一定的量，只是质量参差不齐。如有无金星、满星的价格差别就很大；还有从手串的顺纹、密度、色彩、油性等方面有诸多评判优劣的方法。总之，极品始终是市场的宠儿。从时代上看，小叶紫檀的串珠明清时期就常见，在拍卖行经常可以看到；但与当代小叶紫檀相比，数量要少得多。

小叶紫檀手串

小叶紫檀手串

小叶紫檀珠

小叶紫檀珠

小叶紫檀串珠

17. 天青石串珠。天青石是一种天然宝石。天青石在色彩上变化比较大，从无色直至蓝、绿、橙、浅蓝等色都有见，透明、光泽鲜亮。天青石串珠在市场上比较常见，但总量并不大，可见人们对其的认可度还是有限。但相信，随着珠宝热的深入，天青石串珠一定会越来越火。从造型上看，天青石串珠在造型上以手串、脚链、项链、吊坠等为多见，串联组合也并不复杂，如常见天青石串珠加纯银的吊坠等。从时代上看，天青石的串珠基本上是以当代为主，古代基本上为偶见，或者可以说很少见到。

18. 玉髓串珠。玉髓的矿物组成主要是石英，是一种天然玉石，透明到半透明，平坦状断口，玻璃光泽，淡黄色、绿等色都有见，色彩渐变气氛较为浓郁。从造型上看，玉髓串珠造型十分复杂，手链、脚链、项链、佛珠、念珠、串珠、吊坠等都有见，串联方式也是各种各样。从数量上看，玉髓串珠在数量上非常多，市场上可谓是琳琅满目，成麻袋地批发散珠，可见玉髓串珠之丰盛。从时代上看，玉髓串珠在时代特征上比较明确，以当代为显著特征；古代也有见，但数量比较少。古人是将玉髓作为玉器的一种在使用，并没当代玉髓这样的概念。这一点我们在鉴定时应注意分辨。

19. 玛瑙串珠。玛瑙的矿物组成主要是石英，是一种天然玉石，主要化学成分是二氧化硅，由隐晶质的石英组成，呈现出扁圆形、不规则块状等。玛瑙红、黄、蓝、黑、棕、褐、绿等色都有见，纯色少

南红凉山料手链

战国红玛瑙筒珠

南红凉山料算珠

南红凉山料算珠

见，且珍贵，主要以南红为稀有品种。以柿子红最为贵重，紫红、橙黄、玫瑰红、血红等色彩次之。从数量上看，玛瑙串珠数量相当庞大，各色玛瑙均有被制作成串珠，如黄色、红色、紫色、绿色、蓝色等都有见，但一些珍贵品种数量较少，例如南红保山料和南红凉山料的红玛瑙串珠数量相对于其他玛瑙要少得多，特别是保山料中的优质者数量就更少了，鉴定时我们要注意玛瑙串珠在这种品级上的特征。从造型上看，玛瑙串珠在造型上并没有过大的突破，其本身主要是以算珠形、球形、圆形、扁圆形等为显著特征。造型主要以组佩、发饰、手串、脚链、项链、朝珠、佛珠、多宝串等为多见；串联组合方式也是比较复杂，独立成器和与其他珠宝组合成器的情况都有见。从时代上看，玛瑙串珠在中国的历史中源远流长，如西周时期虢国墓地就出土了许多玛瑙串珠，还发现了较为大型的七璜组玉佩和五璜组玉佩等。实际上玛瑙串珠在当时已经达到历史巅峰状态。当然，玛瑙串珠的历史要比虢国墓早得多，而且直至今日玛瑙串珠一直是兴盛不衰，具有相当强劲的生命力。我们当代玛瑙虽然在串

南红凉山料算珠

七璜组合玉佩 西周

联方式上不及西周时期复杂，但是在时尚性，以及数量上却是远远超过了古代，而且在品质上也超出古代很多。因为古代由于生产力的限制，显然人们在当时并没有寻找到如同南红一样高品质的玛瑙。大多数古代的玛瑙是经过焙烧出来的，这一点我们在鉴定时应注意分辨。

南红凉山料手链

20. 日光石串珠。日光石的矿物名称是奥长石，是一种天然宝石，以黄、棕等色为常见，当然也有其他的色彩，日光效应明显。日光石串珠在当代常见，手链、项链、吊坠、脚链、佛珠等都有见。串珠的串联方式也是比较复杂，其中以手链最为常见。从数量上看，日光石串珠比较常见，在总量上也有一定的量。从时代上看，古代有见，但基本上没有成规模化的情况，可见日光石串珠的流行主要是在当代。

21. 月光石串珠。月光石的矿物名称是正长石，以白色、红色等为常见，透明度为半透明。从数量上看，月光石串珠被众多人所喜爱，被很多人认为是爱情的象征。许多青年男女喜欢互相赠送，所以串珠很多情况下分为男款和女款。一般以手串为常见，非常的漂亮。从时代上看，月光石串珠在中国古代使用并不丰富，多是当代的产品。在造型上，项链、手串、各种珠饰都有见，从出现的频率上主要以手串为主。

22. 珍珠串珠。珍珠是一种天然有机宝石，主要由天然珍珠和养殖珍珠构成，白色、黑色、粉红等色都有见，不透明。从造型上看，珍珠串珠造型比较复杂，以手串、项链、发圈、佛珠等为多见，可见造型之丰富。从数量上看，珍珠串珠非常多，是珍珠的主流造型之一，在总量上十分庞大。从时代上看，珍珠串珠古代也非常流行，直至当代都是非常流行的珠宝。鉴定时应注意分辨。

金色珍珠

白珍珠

珍珠（三维复原色彩图）

23. 变石猫眼串珠。变石猫眼也是比较常见，其矿物名称是金绿宝石，贝壳状断口，在光照的作用下熠熠生辉，具有变色效应。为天然宝石的一种，色彩比较丰富，如黄绿、褐绿、褐色等都有见，有一定的透明度，如同蜂蜜的色彩般诱人，是非常受人们喜爱的一种宝石。猫眼串珠目前在市场上以手链、手串、项链等为常见。猫眼在透明度上比较复杂，从透明到半透明的情况都有见，明暗层次对比鲜明，通体闪烁着非金属的玻璃光泽。猫眼串珠在价格上目前并不高，未来升值的潜力还是比较大。

24. 祖母绿串珠。祖母绿的矿物名称是绿柱石，是一种天然宝石。祖母绿在色彩上以红、黄、蓝、绿等色为多见，色彩较为稳定，玻璃光泽。从数量上看，祖母绿串珠常见，有的是与玛瑙等其他珠宝组合在一起成器；有的是独立成器，但总量并不大。从时代上看，以当代为常见，古代很少见。从器物造型来看，以手链、佛珠、项链、挂件等为多见，其他的器物造型很少见。由此可见，祖母绿在串珠市场上并不是主流，而是显得十分珍贵，这可能与祖母绿在原材上稀少等特征的限制有关。鉴定时应注意分辨。

25. 珊瑚串珠。珊瑚是一种天然有机宝石，珊瑚由珊瑚虫分泌出的外壳组成，中国、日本、阿尔及利亚、突尼斯、摩洛哥、意大利等都有较好的珊瑚产出，特别是中国台湾所产的珊瑚无论在数量还是质量上均居世界第一。从数量上看，珊瑚串珠常见，数量非常庞大，是绝对的主流造型，在总量上有相当的量。从造型上看，珊瑚串珠造型丰富，如手串、项链、挂件等都有见，相互串联组合，十分复杂。从时代上看，珊瑚串珠在时代特征上比较明确，古代就有见。我们来看一则实例，六朝珊瑚项链，M42：4，"已脱落散开（新疆文物考古研究所等，2002），可见在六朝时期，珊瑚串珠就十分常见。当代更是成为一种风尚，珊瑚串珠数量居各个历史时期之首。鉴定时应注意分辨。

莫莫红珊瑚单珠

珊瑚串珠

珊瑚串珠

26. 陶串珠。陶串珠的历史十分久远，可以追溯到原始社会。我们来看一则实例，新石器时代"陶珠，4件。ⅣT3⑦：34，泥质褐陶。椭圆形，有一圆孔。素面。手制。直径1厘米、孔径0.3厘米"（河南省文物考古研究所，2000），这四件陶质珠子呈现出椭圆形，而且中有孔，从尺寸大小上看显然是为了穿系之用。看来，新石器时代人们就已经开始烧制陶珠来进行穿系，并如同我们现代人一样开始佩戴串珠。由此可见，串珠的历史可谓是源远流长。

27. 钻石串珠。钻石的矿物名称是金刚石，一种纯碳组成的矿物，经过琢磨加工后称为钻石。钻石在色彩上有无色、淡黄色，通透，是世界上最硬的石头，硬度达到10，是一种天然宝石。用钻石制作串珠多见用镶嵌的方式，其他方式也有见，各种各样的钻石串珠还是出现了，但总量并不大。

28. 红宝石串珠。红宝石的矿物名称是刚玉，硬度特别大，是公认的最美丽的宝石之一。红宝石串珠有见，有的是以镶嵌的形式存在，有的是项链、串珠等，也有的是红宝石的原石直接穿系。以当代为主，通体闪烁着非金属的玻璃光泽，分外妖娆。

29. 琥珀串珠。琥珀是一种有机宝石，常见有血珀、金珀、骨珀、花珀、蓝珀、虫珀、香珀、翳珀等，形状为饼状、团状、水滴状。目前市场上的琥珀基本上以进口料为主，以波罗的海沿岸国家为主，以俄罗斯的产量最大。另外，美洲、中东、亚洲等都是琥珀出产地。从数量上看，琥珀串珠十分常见，随意的珠宝店内可能都有见，可

血珀串珠

血珀串珠

金珀串珠

见数量之多。在总量上有相当的量，是琥珀主流造型之一。从造型上看，琥珀串珠主要以手串、项链、吊坠链、脚链、佛珠等为显著特征。从时代上看，琥珀串珠在时代特征上比较明确，古代和当代都有见。我们再来看一则实例，"汉代琥珀珠"（辽宁省文物考古研究所等，1999），由此可见，珠形应为汉代琥珀流行的一种时尚，历代不衰，直至当代。鉴定时应注意分辨。

仿花珀手串

血珀串珠

血珀筒珠

血珀串珠

金串珠

仿金串珠

30. 金串珠。金串珠为人们所喜爱。我们来看一则实例，西汉金串饰，"Ⅱ式：4件"（湖南省文物考古研究所等，2001）。实际上这并不是孤例，金质的串珠比较常见，有传统的圆柱、筒珠以及各种式样的珠子，也有颗颗转运珠。这些金质的珠子相互组合在一起，形成手串、项链，以及和各种珠宝等相互结合在一起成器，无论是古代还是当代都十分流行。

31. 兽角串珠。兽角串珠古代和当代都有见，如犀牛角、羚羊角等都是制作珠子的好材料。108 颗的串珠、手串、项链等都有见，主要是明清时期比较常见，之前的古代和当代在数量上都不是太多，可见流行程度有限，并没有真正的兴盛起来。

金串珠

32. 铜串珠。铜串珠在中国古代数量不是很多，但是有见，以圆形串珠等为主，其他造型也有见。如 108 粒的佛珠有见铜珠，一般情况下还和玛瑙等珠宝组合装饰在一起，不过主要还是以铜珠为主。当代铜串珠并不是很常见，可见铜串珠数量是一个衰弱的过程。

33. 沉香串珠。沉香树在受到伤害后，如虫蛀、火烧、雷劈等，在自愈过程中流出的树脂凝聚物，这就是沉香。好沉香质地坚硬、致密，在我国有着几千年的文化史，为众香之首，受到历代帝王将相、文人墨客、才子佳人所追捧。用沉香制作而成的串珠更是令人们趋之若鹜，目前市场上常见，非常贵重，一克万钱。

34. 沉香木串珠。沉香木比较容易理解，就是沉香的宿主，简单说就是沉香树，和沉香是两种东西。市场上也有见用沉香木制作而成的串珠，也有香味，很具有欺骗性。沉香木并不是沉香，价格低廉。我们在鉴定时应注意分辨。

35. 银串珠。银串珠也是串珠当中极为重要的一个品类，如项链就十分常见银串珠，有的是规则的圆形，有的是不规则形的。我们来看一则实例，清代银顶戴，M2：5，"中层球形"（上海市文物管理委员会，1990）。由此可见，球形在顶戴上出现了，而实际上顶戴上的球形只是球形的一种表现形式。多数的串珠是球形，如项链、手链、手排、吊坠、多宝串等，可见造型众多，使人眼花缭乱。当然银器单珠的情况不是很常见，不过在当代是异常流行，这一点我们在鉴定时应注意分辨。

银项链

银项链

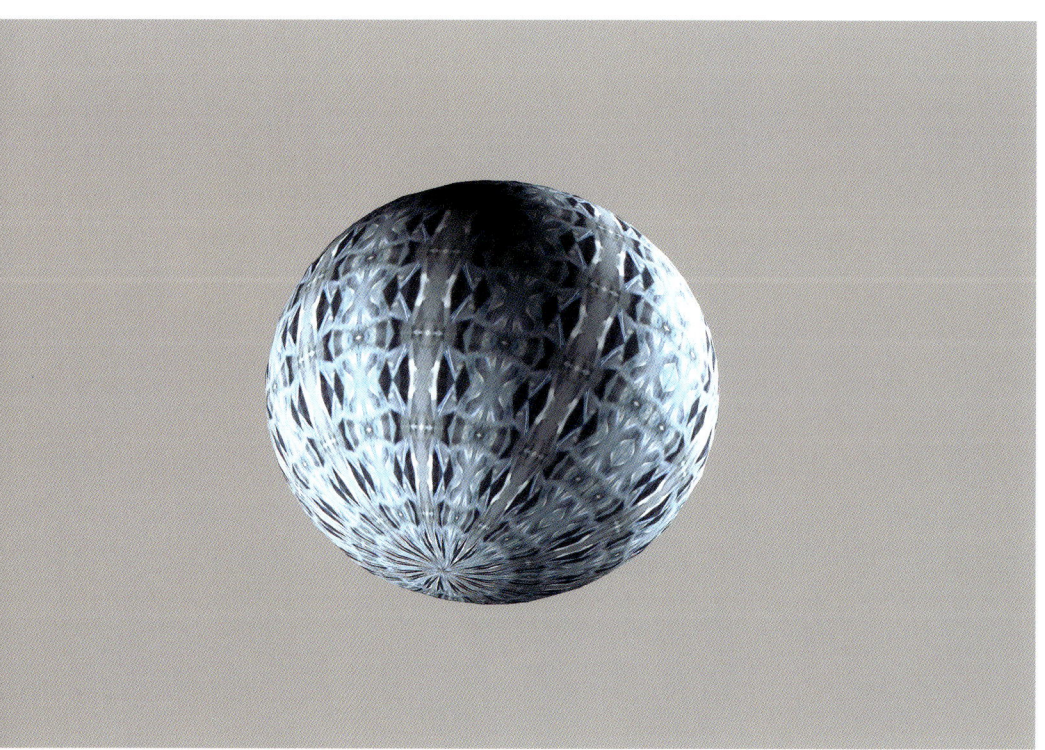

海蓝宝石〔三维复原色彩图〕

36. 海蓝宝石串珠。海蓝宝石的矿物名称是绿柱石，是一种天然宝石。海蓝宝石在色彩上以红、黄、蓝等色为多见，其他偏色和渐变的色彩也有见，透明度很高，光泽鲜亮、润泽，通体呈现出的是非金属的玻璃光泽。从数量上看，海蓝宝石串珠数量非常多，是市场上主流串珠之一。从时代上看，古代很少见，流行的时代主要是当代。从造型上看，海蓝宝石在造型上手串、项链、佛珠等各种串珠都有见，其中以手链最为多见。组合方式多样化，如有简单穿系串联，也有较为复杂的缠绕等。海蓝宝石串珠是市场的宠儿，受到人们的青睐，未来发展潜力很大。

37. 瓷串珠。瓷质的串珠有见，但数量不多，特别是古代数量并不是太多，这可能与瓷器串珠最怕磕碰有关。瓷串珠实用性不是很强，主要以当代较为常见，也有见制作成手链及各种串珠的情况，并不属于高档的串珠类，多在中低端市场上出现，鉴定时应注意分辨。

鲨鱼牙串饰标本

38. 兽牙串珠。兽牙串珠也是较为常见，早期可以追溯到新石器时代。我们来看一则实例，"野猪獠牙组合冠饰，2组。M26：5，成堆出土于墓内头骨顶端，共由14枚獠牙组成。根据大小，它们似可排成两两相配的7对，最小的那对已酥碎。……如此加工显然以利于按插和绑扎固定在冠体上，成为一种威武有力的极好的形象装饰"（浙江省文物考古研究所等，2001）。可见串珠的造型并不仅仅限于圆形的珠子，连缀而成的冠饰应也为串珠的一种。不过牙质串珠已随着时间的流逝逐渐淡去，在当代并不是很流行。

39. 碧玺串珠。碧玺的矿物名称是电气石，是一种天然宝石，在色彩上粉红、红、绿、紫等各种色彩都有见，以品质不同在价格上差距很大。其透明度较杂，光泽鲜亮，具玻璃光泽，贝壳状断口。从造型上看，碧玺串珠在造型上也是比较复杂，手串、项链、挂件等常见，在出现的频率上主要以手串为多，还有一些用碧玺细碎原石连缀而成的项链等，可谓琳琅满目，令人眼花缭乱。从时代上看，碧玺串珠在时代特征上比较明确，主要在当代流行，古代很少见。

40. 蓝宝石串珠。蓝宝石的矿物名称是刚玉，是一种天然宝石。蓝宝石串珠相当名贵，市场上经常有见。有的是镶嵌在一起呈现，如蓝宝石配钻石项链、蓝宝石吊坠，纯粹的蓝宝石珠子串联的串珠等也有见，非常漂亮，收藏者孜孜以求。

橄榄石串饰 橄榄石串饰

　　41. 橄榄石串珠。橄榄石串珠在市场上有见，细碎原石手链、项链等较为常见，多数为绿色，有着色彩深浅浓淡程度的变化，以色彩纯正为最好，透明度很高，光泽淡雅、柔和，具非金属的玻璃光泽，其断口多呈现出贝壳状，真正圆形珠子的手串很少见，克拉大的也很少见，主要是与钻石、黄金、白金等镶嵌后再组成串珠的情况很常见，如 18K 金镶钻吊坠、项链等。橄榄石串珠最为流行是在当代，古代很少见。对其较为倚重的是欧洲国家，而国内橄榄石的热度似乎并不高。

橄榄石串饰（三维复原色彩图）

金丝楠手串

第二节　珍稀串珠

　　1. 金丝楠串珠。金丝楠串珠常见，市场上琳琅满目，在总量上相对有一定的量。从造型上看，金丝楠串珠造型隽永，雕刻凝练，多以手串、项链、佛珠等为主。从时代上看，金丝楠串珠古代有见，特别是清代和民国都比较常见，当代数量更多，可以说量达到了历代之最，可见流行程度之高。

金丝楠串珠

金丝楠手串

金丝楠串珠

金丝楠串珠

2. 水镁石串珠。水镁石的矿物组成主要是水镁石，是一种天然玉石，以白、淡白、淡绿、红褐等色为主，透明。从数量上看，水镁石串珠不是很常见，数量特征较为黯淡，说明不太流行。从时代上看，主要在当代有见，但数量很少，市场上几乎找不到。

3. 葡萄石串珠。葡萄石的矿物组成主要是葡萄石，是一种天然玉石，为参差状断口，以黄绿等色为主，多以半透明为显著特征，通体闪烁着非金属的玻璃光泽。从造型上看，葡萄石串珠主要以手链、脚链、项链、吊坠链等为主，造型本身及串联也不复杂。从数量上看，葡萄石串珠在市场上有见，有一定的量，市场接纳度还可以。从时代上看，葡萄石串珠主要以当代为主，古代很少见。

4. 菱锌矿串珠。菱锌矿的矿物组成主要是菱锌矿，是一种天然矿石，有白、灰、黄、蓝、绿、粉等色，以绿色和蓝色为贵重，半透明，光泽鲜亮。从数量上看，菱锌矿串珠不是很常见，市场上偶见。从造型上看，菱锌矿串珠主要以手串等为显著特征。从时代上看，菱锌矿串珠主要以当代为主，且还没有流行开来。

　　5. 黄金楠串珠。黄金楠串珠有见，在市场上有一定的量。从造型上看，黄金楠串珠主要以佛串、手串、念珠、项链等为多见。从时代上看，黄金楠串珠以当代为主，古代很少见。我们在鉴定时应注意分辨。

　　6. 菱锰矿串珠。菱锰矿的矿物组成主要是菱锰矿，是一种天然矿石，以粉红、玫瑰红等色为常见，不透明，油脂光泽。从造型上看，菱锰矿串珠造型比较简洁，以手串、项链为多见。从数量上看，菱锰矿串珠有见，但市场上比较难找，在总量上很少。从时代上看，菱锰矿串珠以当代为显著特征，尚未流行，但有相当的增值潜力。

　　7. 鹰眼石串珠。鹰眼石的矿物组成主要是石英，是一种天然玉石，贝壳状断口，玻璃光泽，微透明到透明。从数量上看，鹰眼石串珠有见，在总量上有一定的量。从造型上看，鹰眼石串珠以手串、项链等为主。从时代上看，鹰眼石串珠以当代为主。

黄金楠手串

黄金楠手串

黄金楠手串

黄金楠串珠（三维复原色彩图）

黄金楠手串

缅甸花梨串珠

8. 苏纪石串珠。苏纪石的矿物组成主要是苏纪石，是一种天然玉石，黄褐、浅粉红、黑色等常见，树脂光泽、半透。从造型上看，苏纪石串珠造型较简洁，以手串、项链等为主，其他造型不是很常见。从数量上看，苏纪石串珠在数量上较为丰富，在总量上有一定的量。从时代上看，苏纪石串珠以当代为主，古代很少见。

9. 缅甸花梨串珠。缅甸花梨串珠十分常见，市场上琳琅满目，在总量上也是十分庞大。从造型上看，缅甸花梨串珠造型如串珠、项链、108 颗的佛珠等都比较常见，看来还是比较流行。从时代上看，缅甸花梨串珠主要是在当代流行，历史上很少见。鉴定时应注意分辨。

缅甸花梨手串

缅甸花梨手串

缅甸花梨手串

缅甸花梨手串

10. 绿玉髓串珠。绿玉髓（澳玉）的矿物组成主要是石英，是一种天然玉石，贝壳状断口，透明到半透明，玻璃光泽，以绿色为最常见。从造型上看，绿玉髓串珠以项链、手链、脚链等为主，造型比较简单。从数量上看，绿玉髓串珠数量比较多，市场上随处可见，在总量上也有一定的量。从时代上看，绿玉髓串珠以当代为常见，古代很少见。鉴定时应注意分辨。

11. 硅孔雀石串珠。硅孔雀石的矿物组成主要是硅孔雀石，是一种天然玉石，参差状断口，以绿色为主，偏色和串色的情况有见，以不透明为显著特征，在光泽上多数通体闪烁着非金属的丝绢光泽。从数量上看，硅孔雀石串珠有见，但数量并不多，在总量上不是很丰富。从造型上看，硅孔雀石串珠在造型上主要以手链、脚链、串珠等为多见，造型不复杂。从时代上看，硅孔雀石串珠主要以当代为主，历史上很少见。硅孔雀石串珠在当代并未流行开来，目前价位也是比较低，具有相当的发展潜力。

12. 花奇楠串珠。花奇楠串珠在数量上非常多，市场上到处都是，十分流行。它并不属于十分名贵的串珠，价格比较便宜，所以流行程度也特别高。从造型上看，花奇楠串珠造型以手串、佛珠、项链等为主，大小不一、造型不一，以圆球形造型为主。从时代上看，花奇楠串珠以当代为常见。

花奇楠手串

花奇楠手串

花奇楠手串

13. 异极矿串珠。异极矿的矿物组成主要是异极矿，是一种天然玉石，以白、灰、浅黄等色多见，其他的色彩也有，鲜亮与淡雅并存，透明到半透明都有见。从数量上看，异极矿串珠数量并不是很多，并不是特别的流行。从造型上看，异极矿串珠造型比较简单，以手串、脚链、挂件链等为多见。从时代上看，异极矿串珠以当代为主要特征。

14. 蓝玉髓串珠。蓝玉髓的矿物组成主要是石英，是一种天然玉石，其基调色彩为蓝色等，透明到半透明，玻璃光泽。从数量上看，蓝玉髓串珠在市场上常见，有一定的量。从造型上看，蓝玉髓串珠主要以手串、脚链、项链等为常见，以圆球形珠子为显著特征，比较简单。从时代上看，蓝玉髓串珠以当代为常见，古代很少见到。

花奇楠手串（三维复原色彩图）

花奇楠手串

花奇楠手串

非洲花梨串珠

15. 非洲花梨串珠。非洲花梨串珠市场上有见，而且有一定的量。从造型上看，非洲花梨串珠造型以手串、佛珠等为主，项链有时也有见，车挂上也有见，但串联组合方式不是很复杂。从时代上看，非洲花梨串珠以当代为主，其他年代很少见。

16. 火欧泊串珠。火欧泊的矿物组成主要是蛋白石，是一种天然玉石，从橙色到橙红等色彩都有见，贝壳状断口，透明到半透明，光泽淡雅，玻璃光泽。从数量上看，火欧泊串珠并不是很常见，在市场上为偶见。从造型上看，火欧泊串珠以手串、项链等为多见，在具体的造型上以圆球形珠子为显著特征。从时代上看，火欧泊串珠以当代最为常见，古代很少见到。

17. 白欧泊串珠。白欧泊的矿物组成主要是蛋白石，是一种天然玉石，贝壳状断口，主要是以白色基调为主色彩，半透明，玻璃光泽。白欧泊串珠以手串为多见，项链、吊坠等偶见。总之，串珠造型还较有限。从数量上看，白欧泊串珠数量并不多，只是有见。从时代上看，白欧泊串珠以当代为主，古代很少见。由此可见，白欧泊串珠还未在中国真正的流行开来。

非洲花梨串珠

非洲花梨串珠

非洲花梨串珠

非洲花梨串珠

18. 黑欧泊串珠。黑欧泊的矿物组成主要是蛋白石，是一种天然玉石，贝壳状断口，以黑色为主，半透明，玻璃光泽。从造型上看，黑欧泊串珠造型并不多，很少见到有正经的手串等，多是作为镶嵌物与其他珠宝共同成器。从数量上看，黑欧泊串珠很少见，显然未真正流行。从时代上看，黑欧泊串珠以当代为主，古代很少见。

19. 白云母串珠。白云母的矿物组成主要是白云母，是一种天然矿石，褐、红色、无色等都有见，光泽淡雅，为玻璃光泽到丝绢光泽。从数量上看，白云母串珠很少见。

20. 血檀串珠。血檀串珠比较常见，在一般的商场内经常可以看到，特别高级的商场内不会销售血檀，因为这并不是一种非常高档的串珠材质。从造型上看，血檀串珠主要有手串、佛珠等，造型比较简单。从时代上看，血檀串珠以当代为主。

21. 蓝锥矿串珠。蓝锥矿是一种天然宝石。贝壳状断口，颜色为蓝色，偏色的情况有见，渐变的颜色有见，通透，具非金属的玻璃光泽。从数量上看，蓝锥矿串珠数量很少，几乎是处于偶见的状态，这与蓝锥矿比较珍贵也有关系。从造型上看，蓝锥矿串珠主要是与其他珠宝以各种方式组合在一起成器，真正能够单独成器的情况很少见。从时代上看，蓝锥矿串珠以当代为主，古代很少见到，这可能与蓝锥矿过于稀有，过于珍贵有关。它的数量要比钻石少得多。

血檀串珠

血檀串珠（三维复原色彩图）

血檀串珠

血檀串珠

血檀串珠

22. 锂云母串珠。锂云母的矿物组成主要是锂云母，是一种天然矿石，以紫色、黄绿色为多见，光泽鲜亮。从造型上看，锂云母串珠造型比较丰富，手串、脚链、108 粒的佛珠、项链等都有见。从数量上看，锂云母串珠在总量上有一定的量，较为流行。从时代上看，锂云母串珠主要以当代为主，古代很少见到。

23. 绿泥石串珠。绿泥石的矿物组成主要是绿泥石，是一种天然玉石，深绿色，玻璃光泽。从造型上看，绿泥石串珠造型比较简单，手串、项链、佛珠等有见，具体造型主要以圆球形为主。从数量上看，绿泥石串珠不是很常见，其总量很小。从时代上看，绿泥石串珠主要以当代为主，并以机械打磨为主，古代很少见。鉴定时应注意分辨。

24. 透辉石串珠。透辉石是一种天然宝石，以绿色等为常见，透明到半透明，光泽鲜亮和淡雅都有见，玻璃光泽，贝壳状断口。从数量上看，透辉石串珠比较常见，市场上也是琳琅满目，在总量上有一定的量。从造型上看，透辉石串珠以手串、脚链、佛珠、项链、吊坠等为主，特别是手串、项链等多见。从时代上看，透辉石串珠古代很少见，以当代为主，是当代较为流行的串珠之一。

25. 金刚菩提串珠。金刚菩提树是生活在热带、亚热带的常绿大型阔叶树木。菩提子坚硬、致密，非常适合做串珠。目前市场上比较常见，造型隽永，闪烁着非金属的淡雅光泽，非常的漂亮，许多人都喜欢佩戴。价格并不是很高。鉴定时应注意分辨。

26. 顽火辉石串珠。顽火辉石是一种天然宝石，常见的色彩为黑褐色、绿色等，半透明，光泽淡雅，玻璃光泽。从造型上看，顽火辉石串珠以手串、项链等为多见，特别是以手串为多见。从数量上看，顽火辉石串珠并不是很常见，在市场上数量很少，总量几乎可以忽略不计。从时代上看，顽火辉石串珠主要以当代为多见，古代很少见。顽火辉石串珠基本上还未流行开来，这可能与其黑色的色彩等有关。

27. 白云石串珠。白云石的矿物组成主要是白云石，是一种天然矿石，主要成分为碳酸盐矿物，白色，通透。从数量上看，白云石串珠不是很常见，多是与其他珠宝组合成器，自身组成串珠的情况很少见。从造型上看，白云石串珠在造型上特征比较复杂，以项链等为主。从时代上看，白云石串珠以当代为常见。

金刚菩提串珠

金刚菩提串珠

金刚菩提串珠

金刚菩提串珠

28. 朱砂串珠。朱砂串珠市场较为常见，在总量上有一定的量。从造型上看，朱砂串珠以手串、吊坠链、项链、佛珠等为主。从时代上看，朱砂串珠以当代为多见，其他历史时期串珠的造型比较少见。

29. 榍石串珠。榍石是一种天然宝石，常见为浅黄、褐黄等色，其色彩渐变性实际上很强，透明，为玻璃光泽。从数量上看，榍石串珠数量不多，几乎可以忽略不计。从时代上看，以当代为主，古代很少见到榍石串珠的情况，鉴定时应注意分辨。

30. 磷灰石串珠。磷灰石是一种天然宝石，以蓝色、绿色、黄色等为常见，贝壳状断口，透明到半透明，玻璃光泽。从造型上看，磷灰石串珠造型以项链、手串等为主，其他造型不是很常见。从数量上看，磷灰石串珠在数量上常见，但总量并不大，可见流行的程度还是有些弱。从时代上看，磷灰石串珠主要以当代为主，古代所见甚少。

31. 萤石串珠。萤石的矿物组成主要是萤石，是一种天然玉石，为紫、绿等色，有荧光，玻璃光泽。从造型上看，萤石串珠造型丰富多彩，手串、项链、吊坠链、佛珠等都有见，造型和串联方式都较为复杂。从数量上看，萤石串珠比较常见，各种串珠市场上琳琅满目。从时代上看，萤石串珠以当代为主，古代也有见，只是数量不多而已。

朱砂手链

朱砂手链

朱砂手链

朱砂手链

朱砂手链

石榴石串珠

32. 石榴石串珠。石榴石是一种天然宝石。石榴石串珠也是我们在市场上常见到的，如手串、项链、吊坠等都常见，以手串、手链为最多，属中高档的宝石品种。色彩比较多，如红、黄、褐、绿等色都有见。色彩以纯色为最好，在透明度上变化也是比较丰富，从透明到微透明的情况都有见。其光泽淡雅，多数通体闪烁着非金属的玻璃光泽。在数量上较多见，在时代上以当代为主。

石榴石串珠

石榴石串珠

石榴石串珠

石榴石串珠

石榴石串珠

33. 绿帘石串珠。绿帘石是一种天然宝石，是一种以黄绿、绿色等为基调的色彩为主，透明，玻璃光泽。从数量上看，绿帘石串珠比较常见，市场上到处都有见，有一定的量。从造型上看，绿帘石串珠传统的造型，如手串、项链、吊坠等都有见，球体、不规则形的造型都有见。从时代上看，绿帘石串珠在时代上以当代为主，古代很少见，即使在当代流行的时间也不长。鉴定时应注意分辨。

34. 堇青石串珠。堇青石是一种天然宝石，以蓝紫色为显著特征，色彩渐变、串色等比较常见，透明度较高，玻璃光泽。从数量上看，堇青石串珠很少见，几乎可以说是不见。鉴定时应注意分辨。

35. 岫玉串珠。岫玉的矿物组成主要是蛇纹石，是一种天然玉石，以黄绿等色为常见，半透明，蜡状光泽，参差状断口。从数量上看，岫玉串珠在数量上特征比较明确，各种各样的造型，大小不一，以手串、脚链、项链、吊坠链、佛珠等为主要特征，串联方式多样化。从时代上看，岫玉串珠早在新石器时代就有见，直至当代，跨越数千年的岁月长河，一直长盛不衰，为不同时代的人们所青睐。鉴定时注意分辨。

36. 独山玉串珠。独山玉的矿物组成主要是斜长石－黝帘石，是一种天然玉石，微透到透明的情况都有见，玻璃光泽，贝壳状断口。从造型上看，比较复杂，各种造型都有见，但主要是以圆球形为主，

玉璧形串饰·民国

蝴蝶形串饰·清代 蝴蝶形串饰·清代

项链、手串、佛珠等都常见。从数量上看，独山玉串珠比较常见，在总量上有一定的量。从时代上看，独山玉串珠时代悠久，在新石器时代就有串珠类存在，历代经久不衰，直至今日。

37. 锆石串珠。锆石是一种天然宝石，可分为高型和低型两种。高型锆石在色彩上呈现出的多是无色、黄色、蓝色等，渐变性较强，透明度很高，几乎是通透的，玻璃光泽至亚金属光泽的都有，断口呈现出贝壳状。锆石串珠非常的漂亮，在市场上经常有见，手串、项链、吊坠等都有见，从出现的频率上看，主要以手串等为最常见。从时代上看，以当代为最常见，古代并不是很流行。

人工锆石戒指

天河石单珠

天河石单珠

天河石单珠（三维复原色彩图）

38. 柱晶石串珠。柱晶石是一种天然宝石，在断口上为贝壳状，具非金属的玻璃光泽，透明到半透明，从无色到黄色和绿色等都有见。从数量上看，柱晶石串珠很少见，基本上处于偶见的状态。从造型上看，柱晶石串珠比较简单，主要与其他珠宝类组合成为串珠，很少单独成为串珠，因为储量少，并且价格昂贵。从时代上看，柱晶石串珠以当代为主，在古代并不流行，鉴定时应注意分辨。

39. 坦桑石串珠。坦桑石的矿物名称是黝帘石，是一种天然宝石。坦桑石一般为贝壳状断口，在色彩上红褐色、蓝色等都有见，通透、玻璃光泽。从造型上看，坦桑石串珠主要以手链、脚链、项链、吊坠等为多见，特别手串和项链等最为常见。从数量上看，坦桑石串珠在市场上琳琅满目，但在总量上并不大。从时代上看，坦桑石串珠以当代为主，盛行时间并不长。由此可见，坦桑石串珠方兴未艾。

40. 天河石串珠。天河石的矿物名称是微斜长石，是一种天然宝石，以蓝色、绿色为多见；渐变色彩浓郁，从半透明至微透明的情况都有见；光泽也是从鲜亮到淡雅都有见，但以淡雅的光泽为主。从数量上看，天河石串珠有见，但数量并不是很多。从时代上看，以当代为主，古代很少见。造型以手链、项链、佛珠等为多见，其中手链和项链的数量多一些，串联组合方式也不复杂。可见天河石并未在当代形成一种强劲的时尚旋风，只是市场上有见这种串珠而已。

天河石单珠

天河石单珠

天河石单珠

41. 硼铝镁石串珠。硼铝镁石是一种天然宝石。硼铝镁石在色彩上以褐色为常见，有偏色现象，贝壳状断口，透明到半透明，玻璃光泽。从数量上看，硼铝镁石串珠数量并不多，可以说是处于偶见的状态。从造型上看，硼铝镁石串珠造型特征主要是一些镶嵌类制品，也就是说和其他珠宝一起组成串珠等，很少有独立成器的情况。从时代上看，硼铝镁石串珠以当代为主，古代不是很常见。

42. 塔菲石串珠。塔菲石是一种天然宝石，无色、绿色等都有见，贝壳状断口，透明度较好，通透、玻璃光泽。从造型上看，塔菲石串珠基本上都是和其他珠宝共同成器，单独很少能够制作出像样的串珠，因为其原石往往都比较小。从数量上看，塔菲石串珠在数量上很少见，基本上是偶见的状态，远未达到流行的程度。从时代上看，塔菲石串珠在时代特征上以当代为主，古代很少见。

43. 查罗石串珠。查罗石的矿物组成主要是紫硅碱钙石，是一种天然玉石，以紫色为常见，伴随有黑色、白色等的斑点。光泽淡雅、柔和，玻璃光泽至蜡状光泽。从数量上看，查罗石串珠常见，但总量不是很多。从造型上看，查罗石串珠造型比较简单，手串、项链等常见。从时代上看，查罗石串珠以当代为常见，古代比较少见。

44. 绿檀串珠。从数量上看，绿檀串珠比较常见，在总量上有一定的量。从造型上看，绿檀串珠造型较为常见，如手串、佛珠、念珠、项链、脚链等都有见，以圆球形珠为显著特征。从时代上看，绿檀串珠以当代为常见，古代很少见到。

绿檀手串

绿檀手串

绿檀手串

绿檀手串

绿檀手串

猫眼紫檀手串

45. 猫眼紫檀串珠。猫眼紫檀串珠比较常见，市场上到处都有，在总量上有一定的量。从造型上看，猫眼紫檀串珠的造型特征比较清晰，以串珠、佛珠、项链等为主，组合方式比较简单。从时代上看，猫眼紫檀串珠时代特征比较明确，以当代为显著特征，古代很少见。

46. 天蓝石串珠。天蓝石是一种天然宝石。天蓝石在色彩上正如它的名字一样是以天蓝色为基调，并衍生出深蓝、蓝绿等色，半透明到不透明，玻璃光泽至黯淡光泽都有见。从数量上看，天蓝石串珠并不是很常见，在市场上只能说是偶见的状态。从造型上看，天蓝石的造型以手串、吊坠、项链等为常见，以圆珠为主，组合串联并不复杂；从时代上看，天蓝石的串珠在时代特征上比较明确，古代很少见，主要以当代为主。由此可见，天蓝石串珠在当代还未完全流行起来，鉴定时我们应注意分辨。

47. 符山石串珠。符山石是一种天然宝石。符山石中黄绿、绿色等都有见，色彩串色等现象比较严重，半透明，光泽淡雅、柔和，玻璃光泽，参差状断口。从造型上看，符山石串珠以项链、手串、吊坠等为主，主要以项链和手串为多见；从数量上看，符山石串珠还是比较常见，但总量不大；从时代上看，符山石串珠的时代特征很明确，以当代为主，古代很少见，鉴定时应注意分辨。

猫眼紫檀手串

猫眼紫檀手串

猫眼紫檀手串

48. 钠长石玉串珠。钠长石玉的矿物组成主要是钠长石，是一种天然玉石，以灰绿、灰白、白色为常见，无色的情况也很多。光泽淡雅、柔和，油脂光泽至玻璃光泽。从造型上看，钠长石玉串珠造型比较简单，以手串、项链等为常见，尤其是以手串为多见。从数量上看，钠长石玉串珠有见，但数量很少，总体来讲，还未开始流行。从时代上看，钠长石玉串珠主要以当代为主，历史上基本不见。

猫眼紫檀手串

49. 硅铍石串珠。硅铍石是一种天然宝石，这种宝石色彩比较淡，有见无色的，同时也有见黄色，但多以淡黄色为主，透明度较高，玻璃光泽，贝壳状断口。从数量上看，硅铍石串珠并不是很常见，数量很少。从造型上看，硅铍石串珠在造型上并不是很丰富，甚至从目前市场上的情况来看，还未形成有效的特点，因为数量太少了，偶见一些由原石组合而成的串珠。从时代上看，以当代为主，古代很少见。

50. 鱼眼石串珠。鱼眼石是一种天然宝石，多数为浅蓝色的晶体，透明，光泽鲜亮，通体闪烁着非金属的玻璃光泽。从数量上看，鱼眼石串珠并不常见，市场上只是偶见有一些。从造型上看，鱼眼石串珠的造型，以项链、吊坠、毛衣链等为主，有效特征并不明确，这是由于数量太少的缘故。从时代上看，鱼眼石串珠时代特征很明确，人们有意识的使用就是在当代，古代很少见到，即使有使用也是无意识的。

51. 蔷薇辉石串珠。蔷薇辉石的矿物组成主要是蔷薇辉石、石英，是一种天然玉石，断口为贝壳状，色彩以粉红色为主，为半透明，具玻璃光泽。从数量上看，蔷薇辉石串珠常见，市场上琳琅满目，人们非常喜欢，比较流行，在总量上有一定的量。从造型上看，蔷薇辉石串珠造型比较丰富，佛珠、项链、手链等都有见，以手串为比较常见，有男串和女串之分，造型有时较为复杂。从时代上看，蔷薇辉石串珠以当代为主，古代很少见。

52. 柯檀串珠。柯檀串珠有见，相对来讲数量少一些，但是在总量上也有一定的量。从造型上看，柯檀串珠特征比较明确，以串珠、项链、佛珠等为常见。从时代上看，柯檀串珠以当代为主，古代很少见。

柯檀手串

柯檀手串

柯檀手串

柯檀手串

柯檀手串

玫瑰金丝楠手串

53. 玫瑰金丝楠串珠。玫瑰金丝楠串珠有见，有一定的量，但相对于花奇楠串珠在数量上少一些。从造型上看，玫瑰金丝楠串珠以佛珠为主，大小不一。从时代上看，玫瑰金丝楠串珠时代特征十分清晰，主要是在当代流行，古代基本不见。

玫瑰金丝楠手串

玫瑰金丝楠手串

玫瑰金丝楠手串

玫瑰金丝楠手串

54. 磷铝钠石串珠。磷铝钠石是一种天然宝石，无色、有时呈现出黄绿色等，具非金属的玻璃光泽，透明到半透明。从数量上看，磷铝钠石串珠相当少见，多为偶见的情况。从造型上看，打磨好的圆珠很少见，有的就是原石打孔用红绳穿起来的手串；项链等造型也有见，但数量很少。从时代上看，主要是当代有少量见，古代所见很少，看来磷铝钠石串珠的流行还需要时间积淀。

55. 赛黄晶串珠。赛黄晶是一种天然宝石。赛黄晶在色彩上比较丰富，从无色到浅黄、褐色等的色彩都有见，具玻璃般鲜亮光泽，透明。赛黄晶串珠有见，但数量有限。从造型上看也是这样，虽然赛黄晶宝石常见，但真正制作成串珠的少见，特别是手链、项链等就更少见，这可能与价格昂贵有关系。但无论怎样，目前赛黄晶串珠虽还未真正地流行，将来这种造型必将成为一个热点。从时代上看，赛黄晶串珠主要是在当代有可能见到，在古代实际上是很少见到的。

56. 阳起石串珠。阳起石的矿物组成主要是阳起石，是一种天然玉石，成分为硅酸盐类矿物，非金属玻璃光泽，透明到不透明，以白色、浅灰等为常见。从造型上看，阳起石串珠以手串等为多见，是送礼的佳品，特别是习惯于送男士的礼物。从数量上看，阳起石串珠在数量上并不是很常见，只是偶有见，可见还远未流行开来。从时代上看，阳起石串珠以当代为主，古代很少见。

黑檀串珠

黑檀串珠

57. 黑檀串珠。黑檀串珠在数量上比较常见，市场上到处都是，总量比较大，较为流行，但并不是一种珍贵串珠。从造型上看，手串、项链、佛珠等都有见。从时代上看，黑檀串珠以当代为主，古代很少见。鉴定时应注意分辨。

58. 透视石串珠。透视石是一种天然宝石，以绿色、蓝色泛绿等为主，玻璃光泽，光泽淡雅、柔和，透明度较为复杂，从半透明到透明的情况都有见。从数量上看，透视石串珠比较少见，多数是装饰在服装之上，独立成器的情况很少见。从时代上看，古代很少见，以当代为主。由此可见，透视石串珠在当代远未达到流行的程度。我们在鉴定时应注意分辨。

59. 蓝柱石串珠。蓝柱石是一种天然宝石。蓝柱石在色彩上比较复杂，从无色到白色、浅蓝、灰绿等都有见，贝壳状断口，玻璃光泽。蓝柱石手串目前在市场上并不是很常见，造型多是与其他珠宝组合成器，单独成器的情况很少见；有见简单手串出现，远没有达到流行的程度。从时代上看，以当代为主，过去很少见。鉴定时应注意分辨。

60. 水钙铝榴石串珠。水钙铝榴石的矿物组成主要是水钙铝榴石，是一种天然玉石，以黄绿色为常见，透明度较高，为半透明，玻璃光泽，贝壳状断口。从造型上看，水钙铝榴石串珠主要以手串、项链为主。从数量上看，水钙铝榴石串珠不是很常见，总量很小。从时代上看，水钙铝榴石串珠以当代为主，古代很少见，看来还没有流行开来。

黑檀串珠

黑檀串珠

黑檀串珠

黑檀串珠

桃木串珠

桃木串珠

61. 桃木串珠。桃木串珠较为常见，市场上如雨后春笋般地兴起，到处都是，在总量上有一定的量。从造型上看，桃木串珠以各种各样的手串、项链、佛珠等为多见。从时代上看，桃木串珠以当代为主，历史上很少见到。

62. 锡石串珠。锡石是一种天然宝石。锡石是一种无色至浅黄等色的宝石，透明度很好，金属光泽，断口为贝壳状。从造型上看，锡石串珠数量上很少见，市场上见到的基本上都是锡石矿物晶体，或者可以镶嵌的多棱体小戒面等，这可能与锡石自身过于少的特点有关系，以当代为常见。由此可见，锡石串珠至今还未开始流行，是一种较有潜力宝石品种，只是在串珠上较为黯淡。

63. 磷铝锂石串珠。磷铝锂石是一种天然宝石，其色彩为白色，半透明，玻璃光泽。磷铝锂石串珠在数量上有见，但数量很少。从造型上看，磷铝锂石主要是以镶嵌类为主，和其他珠宝一起共同组合成器，单独为串珠的情况几乎不见。从时代上看，中国古代有见这种质地，但串珠的造型基本不见，主要还是以当代为常见，也是一种还未流行的珠宝。

64. 滑石串珠。滑石的矿物组成主要是滑石，是一种天然玉石，浅黄色、灰白色、浅红色等，不透明，为蜡状光泽，淡雅、柔和。从数量上看，滑石很少用来制作串珠类的造型。鉴定时应注意分辨。

桃木串珠

桃木串珠

桃木串珠

桃木串珠

65. 青金石串珠。青金石的矿物组成主要是青金石，是一种天然玉石，以蓝色为基调，浅蓝、深蓝、青蓝等不同的色彩都存在，有的色彩上还带有一些不同白点，不透明，玻璃光泽，参差状断口。从数量上看，青金石串珠数量相当多，市场上琳琅满目，到处都是，给人以一种非常多的感觉。青金石等级比较分明，一般都是由色彩的纯正程度和大小来区分的，最纯、最大者质量最好，但数量最少，价格最高。不过，有的时候珠宝具有特殊性，并不是说有钱就可以买到最好的，这主要是要靠缘分。从造型上看，青金石串珠造型比较丰富，如手串、脚链、项链、吊坠链、多宝串等都有见，造型串联方式并不是很复杂，主要是以圆珠为主。从时代上看，青金石串珠特征不是很明确，古代和当代都有见，如《清史稿·舆服志二·皇贵妃以下冠服条》"中间金衔青金石结二，每具饰东珠、珍珠各六，末缀珊瑚。"由此可见，其实在古代串联的方式还是多样化的，当代更是常见；青金石串珠无论古代还是当代都非常流行。

66. 冰洲石串珠。冰洲石的矿物名称是方解石，是一种天然宝石。从色彩上看，多为白色，以半透明为常见，玻璃光泽浓郁。从数量上看，冰洲石串珠很少见，处于偶见的状态。造型主要是和其他如水晶等制品组合成器，自己单独成器的情况很少见，可见人们对于冰洲石的认识还有待提高。从时代上看，主要是以当代为主，在古代基本不见。

青金石串珠

青金石串珠

青金石串珠

67. 斧石串珠。斧石是一种天然宝石，是人们所熟悉的。其色彩以紫、褐等色为基调，如紫褐色就比较常见，透明度较高，多数是通透的。从造型上看，斧石串珠有见，主要是与其他的珠宝组合成器，很少见到独立成器的情况，可见人们对于斧石还缺乏了解。从数量上看，斧石串珠数量相当有限，可以说极为稀少，且在时代上以当代为主，古代很少见到。可见斧石串珠还没有流行的趋势，这可能与珠宝种类过多也有关系，有一些宝石实际上质地不错，但是由于不为人们所熟悉，所以基本就不流行。但也正是这样的宝石才更具有保值和升值的潜力，因为其价格有的根本就没有起飞过，我们在收藏时应特别注意这些宝石品类。

68. 硅硼钙石串珠。硅硼钙石的矿物组成主要是硅硼钙石，是一种天然玉石，以白、浅绿、褐、灰色等为常见，无色者有见，玻璃光泽，透明到半透明。从造型上看，硅硼钙石串珠造型比较复杂，宽的、窄的、扁的、圆的都有见，大小不一，主要以手串、项链等为多见。从数量上看，硅硼钙石串珠比较常见，在总量上有一定的量。从时代上看，硅硼钙石串珠时代特征鲜明，以当代为常见，古代不是很常见。

青金石串珠

青金石串珠

青金石串珠

69. 锂辉石串珠。锂辉石是一种天然宝石。锂辉石多为粉红色等，色彩艳丽、通透，具玻璃光泽。从造型上看，锂辉石串珠造型并不复杂，主要以手链、脚链、吊坠、项链等为多见，数量并不算是丰富，但多数是造型隽永。从数量上看，锂辉石串珠在数量上特征很明确，市场上有见，但不是太多。从时代上看，主要是当代有见，古代很少见。由此可见，锂辉石串珠流行的时代主要是当代，但从数量上看，这一种类的串珠产品似乎价值还远没有被大众所认可，其发展的潜力还是比较大。

70. 蓝晶石串珠。蓝晶石是人们所熟悉的一种天然宝石，色彩为灰蓝等色，晶体透明度比较高，通体闪烁着玻璃光泽，参差状断口。从时代上看，蓝晶石串珠在古代很少见，也是以当代为主要特征，这与当代社会稳定和盛世有关，很多在古代没有或者是很少的宝石在当今盛世都出现了。从造型上看，蓝晶石串珠主要以项链、串饰、手链、佛珠等为常见，其中项链和吊坠等数量比较多。从总量上看，蓝晶石串珠在数量上有见，但并不是太多，与主流串珠没有关系。这一点我们在鉴定时应注意分辨。

71. 孔雀石串珠。孔雀石的矿物组成主要是孔雀石，是一种天然玉石。孔雀石为参差状断口，以绿色为主，不透明，有丝绢光泽。从造型上看，孔雀石串珠在造型上特征很明确，以串珠、项链等为显著特征，造型比较简单。从数量上看，孔雀石串珠在市场上也是比较常见，在总量上有一定的量。从时代上看，孔雀石串珠的时代特征比较明确，以当代为主，古代不是很常见。

孔雀石手串

孔雀石手串

孔雀石手串

孔雀石手串

孔雀石手串

孔雀石手串

72. 方柱石串珠。方柱石是一种天然宝石，色彩以紫色等为多见，通透，有着较强的玻璃光泽。从数量上看，方柱石串珠在数量上并不是很丰富，在市场上还很难找到。造型主要以手串、项链等简单造型为主，形式不是很多，以手串为常见。从时代上看，也是以当代为主，古代很少见，这可能与古代人们对于这种材料的认识有关，看来方柱石串珠还并未在当代真正流行起来。

73. 普通辉石串珠。普通辉石是一种天然宝石，这种宝石色彩比较丰富，浅绿色、黑色等都是比较常见，不透明，玻璃光泽。从时代上看，古代很少见，主要以当代为常见。从数量上看，当代普通辉石串珠也只是偶有见，并不普及。从造型上看，普通辉石串珠在造型上并不是很丰富，多是以圆形珠子为显著特征，串联方式也多是以简单为主，如项链、手串等都常见。鉴定时注意分辨。

74. 羟硅硼钙石串珠。羟硅硼钙石的矿物组成主要是羟硅硼钙石，是一种天然玉石，以白色和灰白等色为主，具淡雅的玻璃光泽。从数量上看，羟硅硼钙石串珠较为少见，不过多赘述。

虎睛石手串

虎睛石手串

75. 虎睛石串珠。虎睛石的矿物组成主要是石英，是一种天然玉石，贝壳状断口，有见通透者，同时也有见半透的情况，多数通体闪烁着玻璃光泽。从造型上看，虎睛石串珠比较复杂，圆球形珠、扁圆形珠、扁珠等都有见，手串、项链、吊坠串等都有见。从数量上看，虎睛石串珠数量比较多，市场上随处可见，是主流串珠之一。从时代上看，虎睛石串珠以当代为主，古代很少见。

虎睛石串珠（三维复原色彩图）

虎睛石手串

虎睛石手串

虎睛石手串

虎睛石手串

76. 托帕石串珠。托帕石的矿物名称是黄玉，是一种天然宝石，无色、黄、褐等色都有见，光泽淡雅、柔和，具玻璃光泽，透明度很高。从时代上看，古代有见，但并不是特别的常见，远未形成一种风尚的程度；当代受到国外托帕石情结的影响，在我国特别的流行，是最主要的串珠造型之一。从数量上看，托帕石串珠的数量比较多，市场上到处都可以见到，显然已经形成一种风尚。从造型上看，托帕石串珠主要以手链、吊坠、项链、佛珠等为主，其中最为常见的是手链、项链等。具体珠子的造型也是比较丰富，圆形、扁圆、菱形等都有见，串联方式也是较为多样化。鉴定时应注意分辨。

77. 拉长石串珠。拉长石是一种天然宝石，拉长石的色彩比较丰富，红、黄、蓝、绿、紫等色都有见，半透明到透明的情况都有见，玻璃光泽。拉长石串珠在当代比较流行，古代也有见，但以当代为主。从造型上看，以传统的手串、脚链、项链、吊坠等为多见，出现频率以手串为最多。从数量上看，目前市场上有一定的量，但总量并不大。因此，拉长石串珠并未在当代成为主流，只是当代众多串珠中的一种而已。

78. 方钠石串珠。方钠石的矿物组成主要是方钠石，是一种天然玉石，参差状断口，多为蓝色、不透明，具玻璃光泽。从造型上看，方钠石串珠手串、项链、佛珠等都有见，造型比较丰富。从数量上看，方钠石串珠较为常见，市场上很容易找到，在总量上有一定的量。从时代上看，方钠石串珠以当代为主，历史上很少见，鉴定时应注意分辨。

79. 绿松石串珠。绿松石的矿物组成主要是绿松石，是一种天然玉石，以绿色、蓝色为常见，不透明，蜡状光泽。从数量上看，绿松石串珠市场上到处都是，特别是湖北市场上绿松石串珠特别多。从造型上看，比较复杂，手串、脚链、佛珠、多宝、念珠、项链等都有见。从时代上看，绿松石串珠的时代可以追溯到新石器时代。我们来看一则实例，"绿松石珠146粒。多与骨珠相间串成链饰。95TZM216：1，圆柱形。"（青海省文物管理处等，1998）。绿松石串珠各个时代都有见，直至当代，依然在继续着它的传奇。

优化绿松石串珠

优化绿松石串珠

优化绿松石串珠

80. 钙铁榴石串珠。钙铁榴石是一种天然宝石。钙铁榴石在色彩上比较丰富，如黄色、绿色、黑色等都常见，玻璃光泽，光泽淡雅、柔和。钙铁榴石串珠数量比较丰富，各种各样的串珠都有见，但出现频率较高的应属手串。从时代上看，钙铁榴石串珠在时代特征上也很明确，以当代为主，古代很少见。

81. 尖晶石串珠。尖晶石是一种天然宝石。尖晶石的光泽较为显眼，为玻璃光泽，并且光泽较亮；贝壳状断口，色彩为红、绿、紫、黑等各种色彩都有见，透明。从造型上看，市场上尖晶石手链、项链、佛珠等都有见。从数量上看，有一定的量，但总量不大，这说明尖晶石串珠并不是特别流行。从时代上看，尖晶石串珠流行的时代是当代，古代很少见，这可能与古代的开采能力不发达有关。鉴定时应注意分辨。

82. 龟甲串珠。龟甲是一种天然有机物，其材料就是龟甲，黑褐色，不透明。从数量上看，龟甲串珠并不是很常见，在总量上也不多。从造型上看，主要以手串、项链等为多，以扁形为主。从时代上看，龟甲串珠主要以当代为主，古代串珠造型很少见。

83. 黑曜岩串珠。黑曜岩的矿物组成主要是天然玻璃，是一种天然玉石，以黑色或黑褐色为多见，透明到半透明，具玻璃光泽。从造型上看，黑曜岩串珠造型以圆珠为常见，手串、项链为多见。从数量上看，黑曜岩串珠很常见，在总量上有一定的量。从时代上看，黑曜岩串珠主要是当代比较流行。

黑曜石手串

黑曜石手串

黑曜石手串

黑曜石手串

黑曜石手串

黑曜石手串

黑曜石手串

84. 钙铬榴石串珠。钙铬榴石是一种天然宝石，为石榴石的一种，色彩与祖母绿较为相似，但也有渐变的成分在里面。在透明度上比较好，玻璃光泽，断口为贝壳状。这种宝石数量很少，主要以戒面等为主，真正作为串珠出现的情况很少见。从时代上看，无论古代还是当代都是这样，但从理论上讲，作为串珠也是无可厚非的事情。

85. 钙铝榴石串珠。钙铝榴石是一种天然宝石，为石榴石的一种。从色彩上看，这种石榴石在色彩上比较明确，以红、绿、淡绿、淡黄等色为常见，但偏色现象也是时有发生；多数通透，具玻璃光泽，淡雅、柔和，贝壳状断口。从数量上看，钙铝榴石串珠并不是很常见，这可能是人们的习惯问题。从时代上看，当代有见，古代很少见。

86. 玻璃陨石串珠。玻璃陨石的矿物组成主要是天然玻璃，是一种天然玉石，以褐色、深褐色、墨绿色、绿色等为多见，其他的色彩也有见，半透明，具玻璃光泽。从数量上看，玻璃陨石串珠市场上有见，但数量不是很多。从造型上看，玻璃陨石串珠在造型上比较简单，以手串、项链等为显著特征。从时代上看，玻璃陨石串珠的时代特征比较明确，以当代为主，古代很少见。

87. 针钠钙石串珠。针钠钙石是一种天然玉石，无色、白色和灰白色等都有见，参差状断口，光泽淡雅。从数量上看，针钠钙石串珠有见，但数量很少，在总量上几乎可以忽略不计。从造型上看，针钠钙石串珠主要以手串、项链等为主。从时代上看，针钠钙石串珠主要以当代为常见，古代很少见。

针钠钙石单珠

针钠钙石单珠

砗磲于串

砗磲手串

88. 铁铝榴石串珠。铁铝榴石属于石榴石的一种，在色彩上为深红等色，渐变和偏色等现象有见，通体都是玻璃光泽，断口为贝壳状。在透明度上，半透明到透明的情况都有见，是制作串珠的好材料之一。从造型上看，108 粒的佛珠、手串、手链、项链等都有见。从数量上看，不是很常见。从时代上看，古代很少见，以当代最为常见。

89. 锰铝榴石串珠。锰铝榴石属于石榴石的一种，在色彩上主要以橙黄等色为主，色彩比较稳定，但渐变色彩已然有见，同时闪烁玻璃光泽，光泽鲜亮、淡雅、不刺眼，透明、贝壳状断口。从时代上看，主要以当代为常见，古代所见不多。从数量上看，在总量上有一定的量。鉴定时注意分辨。

90. 硅化木串珠。硅化木是一种天然有机宝石，颜色黄褐、红褐、灰白、灰黑等都有见，玻璃光泽，透明到微透明。从造型上看，硅化木串珠以手串、项链等为主。从数量上看，硅化木串珠较为常见，但总量不大。从时代上看，硅化木串珠以当代为主，历史上不多见。

91. 砗磲串珠。砗磲是一种天然有机宝石。砗磲是一种大的贝类，材质光滑、润泽、温润。从造型上看，砗磲串珠造型较为复杂，以手串、项链、吊坠链、佛珠等为多见。从数量上看，砗磲串珠数量比较多，市场上常见，在总量上有一定的量。从时代上看，砗磲串珠古代有见，但数量有限，以当代为主，当代砗磲在数量上相当丰富。

砗磲手串

砗磲手串

砗磲手串

92. 矽线石串珠。矽线石是一种天然宝石，褐色、浅绿色、白色等都有见，可见在色彩上比较丰富，但纯正的色彩不是很多，主要是以组合色彩和渐变色为主。在光泽上，十分光亮，反射光的能力很强，同时闪烁着非金属的玻璃光泽；透光程度不是很好，多数是微透明，似透非透的感觉。矽线石串珠十分常见，造型各种各样，以圆形、扁圆形、菱形等为多见；器物造型以手串、项链、手链等都有见。从时代上看，矽线石串珠以当代为常见，古代很少见。

93. 镁铝榴石串珠。镁铝榴石是一种天然宝石，为天然石榴石的一种。从色彩上看，以红褐色为主，但在色彩上渐变成分比较重。从透明度上看，镁铝榴石透明度较高，通透性较好，光泽鲜亮，通体闪烁着非金属的玻璃光泽。镁铝榴石串珠比较常见，如1厘米左右的圆形等串珠都是比较常见，以手串、串珠、项链等为多见。从时代上看，以当代为常见，古代很少见。从数量上看，在总量上有一定的量。

94. 赤铁矿串珠。赤铁矿是一种天然矿石，贝壳状断口。赤铁矿在色彩上以灰色为主，完全不透明，具金属光泽。从数量上看，赤铁矿串珠市场上有见，但不是太多。从造型上看，赤铁矿串珠造型比较简单，以手串和项链为多见。从时代上看，赤铁矿串珠在当代较为流行，古代并不是很常见。

95. 骨串珠。骨串珠的历史也是十分久远，可以追溯到新石器时代。我们来看一则实例，"骨珠，4536粒。一般是用鸟肢骨截成的小圆柱，通过骨腔串系成链饰，佩戴于头、颈、手腕、足踝等处，少者

"全唐佛像"骨珠·民国

"全唐佛像"骨珠·民国

几十粒,多者如95TZM130:3,达3713粒之多"(青海省文物管理处等,1998)。可见当时的骨珠是多么的流行,墓主人全身都是珠子。商周以降,直至当代都有见,只是骨串珠在以后的岁月当中流行程度是逐渐在下降,特别是我们当代不是很流行。

96. 变石串珠。变石串珠的矿物名称是金绿宝石。自然光下呈现出的是绿色,而在灯光下呈现出的则是淡淡的红色,故而得名。变石在透明度上特征鲜明,透明、半透、不透明的情况都有见,相当漂亮,熠熠生辉。当代市场上常见,以手链、项链、手串等为多见,有一定的量。

97. 煤精串珠。煤精是一种天然有机宝石,其材料实质就是褐煤,主要以黑色为基调,色彩渐变的情况也有,不透明,非金属油脂光泽,贝壳状断口。从数量上看,煤精串珠有见,但不是太多,总量十分有限,这主要是受到资源的限制。从造型上看,煤精串珠在造型上主要以手串、项链等为多见。从时代上看,煤精串珠古代有见,如河南三门峡西周虢国墓地M2001号国君大墓就曾出土过一件煤精串饰,可见,煤精串珠可以追溯到遥远的西周时期,之后历代不衰,直至当代。

煤精绿松石串饰·西周

98. 空晶石串珠。空晶石的矿物名称是红柱石，是一种天然宝石，多呈现出以粉红色、红色等为基调的色彩，在色彩上有一定的渐变性；在透明度上特征比较复杂，不同的空晶石透明程度不同，有的透明，有的只是微透或者是半透明，在同一件空晶石矿上透明度并不均匀；多数通体闪烁着非金属的玻璃光泽，光泽淡雅、柔和，并不刺眼。空晶石串珠在市场上有见，但数量并不是太多，看来空晶石串珠还未受到人们真正的追捧。

99. 翠榴石串珠。翠榴石是一种天然宝石，为石榴石的一种，透明度比较好，玻璃光泽，断口为贝壳状。其串珠的造型有手串、项链等，原石穿系在一起组成手串的情况常见。从时代上看，以当代为多见，古代很少见到。从数量上看，市场上并不是很常见，市场还有待于培育。

100. 黑榴石串珠。黑榴石是一种天然宝石，为石榴石的一种。色彩为黑色等，微透明，光泽淡雅、柔和，同时闪烁着非金属的淡雅光泽，属玻璃光泽的范畴。这种串珠非常受到人们的欢迎，是石榴石作为串珠的主流质地。从造型上看，一些大型的串珠，如108颗的佛珠、手链等都有见。从时代上看，以当代为主，古代很少见。

珠宝辐射

　　珠宝是美丽的，但它具有其自然属性的一面，这一点是本书需要提醒读者，与读者共勉的。一般来讲，天然的珠宝危害性不大，因为这些珠宝的原石宝石都是与地球岩石一起共生，其放射性早已衰变，不具危害性。较麻烦的就是人工辐射的情况。一般情况下，人工辐射后要放置一段时间才能上市销售，所以危害性基本不存在。但是这是正规厂家的做法，一些小厂根本是不讲究这些的，所以在购买珠宝时一定要选择正规生产企业，再者多选择天然的。但是目前市场上还是有不和谐音符。如众所周知，锆石分为高型和低型。锆石低型辐射较为严重，可以穿透人体，对于人们的身体有损害。但是低型锆石在市场上偶尔有见，可能销售它的人也不懂，这个时候应迅速告之，赶快避开。宝石虽美，但有的时候越是美的东西越是冷艳的，所以我们要多研究，要取其精华，而剔除糟粕，将宝石带给人们的伤害降到最低。总之，一定要到正规的商场和有信誉的知名企业购买，或者是咨询专家、学者，这样可以将危害性降到最低。

人工锆石标本

朱砂手链

第二章　串珠造型

第一节　常见造型

一、圆球形

圆球形的串珠常见，是各类质地串珠的主流造型，我们来看一则实例，"东汉琥珀珠 28 粒"（广西文物工作队等，1998）。由此可见，东汉时期琥珀珠已经很常见，并不是只有我们当代才有琥珀串珠，汉代有很多像这样的实例。我们再来看一则，"汉代琥珀珠"（辽宁省文物考古研究所等，1999）。由此可见，不同地区的汉墓中出土了相同造型的珠形琥珀，珠形应为汉代琥珀流行的一种时尚。蜜蜡当中球形的造型最为常见，大多数珠子的形状是球形，人们将蜜蜡磨制成大小不一的珠子，中间打孔后用绳子穿起来，成为串珠、手链、项链等装饰品。从数量上看，圆球形的珠子是各类串珠中的主流，在总量上最多，这一点无论是古代还是当代无疑都是如此。从规整程度上看，以当代为主，当代基本上都是用机器磨圆成珠子的球体，误差率很低，相当漂亮，造型规整。当然手工制作也是相当规整，但是从总体上显然是没有机械打磨的整齐划一。

南红凉山料圆珠

茶晶串珠

血珀串珠

蜜蜡串珠

小叶紫檀手串
（三维复原色彩图）

二、圆管形

圆管形的造型本身比较容易理解，就是圆形管状的造型。我们来看一则实例，春秋战国水晶管"M535：12，圆管状"（中国社会科学院考古研究所洛阳唐城队，2002），可见圆管形的造型在春秋战国时期就在水晶上呈现了。但这还不是管形出现的最早时间，早在新石器时代，管形的串珠就已经出现了，而且琢磨都是几无缺陷。如一些绿松石管、玉管等，特别是在早期圆管形的造型被广泛应用于串珠之上。西周虢国墓地中就出土了大量连缀有圆管形的串饰，直至当代依然非常兴盛。总之，这是串珠造型当中十分重要的形制。鉴定时应注意分辨。

仿蜜蜡手串（筒珠）

<div align="right">战国红玛瑙筒珠</div>

<div align="right">鸡翅木串珠（三维复原色彩图）</div>

三、方　形

　　方形在串珠上的应用也是比较广泛。如长方形管组合而成的项链、手串等都有见。我们来看一则实例，西汉水晶珠"长方形"（广州市文物考古研究所，2003）。由上可见，长方形的造型在西汉水晶珠上出现了。这的确是一种打破我们当代人思维方式的造型，因为水晶珠在我们当代人的感觉里就是球体的，而不是长方形，但是在古人的概念里从这个实例来看应该还有更多的造型，这种造型多流行于商周秦汉时期，之后很少见到。当时方形管还是比较常见，我们再来看一件实例，"明代琥珀项链，M29∶28，另有一块为长方形"（南京市博物馆等，1999）。由此可见，这件琥珀项链为多种形状的组件组成。从时代上看，方形串珠以古代为主，当代有见，但数量很少。鉴定时应注意分辨。

战国红玛瑙算珠

四、扁圆形

扁圆形的串珠造型十分常见。我们来看一则实例，战国紫晶珠"扁圆体"（淄博市博物馆，1999），可见这件战国时期的紫晶珠是扁圆形，而我们知道珠的造型在水晶当中最为丰富，是串珠的组合件。实质上扁圆形的造型在器物造型上表现不仅仅是水晶珠，如手串、项链、佛珠等都有见扁圆形，可见其流行的程度之广。我们来看一则实例，"明代琥珀项链，M29：28，琥珀珠大多为扁圆状"（南京市博物馆等，1999）。当然，扁圆形在珊瑚、和田玉等诸多材质上都有表现，例子就不再赘举。从具体的造型上看，古代扁圆形的造型主要以手工制作为主，因此所谓扁圆不过是视觉意义上的概念。从时代上看，实际上扁圆形的造型在新石器时代就有见；商周时期同样有见；秦汉以降，直至明清都有见；当代更是十分流行。从规整程度上看，当代串珠扁圆形的造型在机械化工艺下，变得十分规整；而手工制作的，在造型的细微变化上比较丰富。鉴定时注意分辨。

金色珍珠

白珍珠

五、圆柱形

圆柱形的造型比较常见。圆柱体是立方体的水平旋转，这种造型实际上也是串珠本体造型的一部分。此种造型广泛应用于各种质地的器皿。当然古代柱状造型显然并不是真正意义上的几何造型，而是以视觉为判断标准，偏扁圆一些的，或者是只要看起来像是圆柱体的，我们一般都将其归入这一类。我们来看一则实例，战国紫晶串饰"柱状"（淄博市博物馆，1999）。可见，柱形在串饰上出现了，而且是在较为古老的战国时期。其实，这种造型不仅是在战国时期，汉唐已降，包括我们当代都是比较流行。这种造型在水晶中经常被应用到各种造型之上，与其单独成形最接近的是筒珠，筒珠的造型比较丰富，无论是我国古代还是现代都常见，可以作为挂件单独存在，也可以作为组件，制作成手串等。从流行程度上，各个历史时期都有见，直至当代。从规整程度上看，多数造型规整、圆度规整，具有相当的视觉震撼力。但由于手工制作，不规整的情况也有见，如汉代水晶组合串饰"第四组　M6a：77……蓝、白色水晶10件，有菱形、扁圆形及不规则方柱形"（广西壮族自治区文物工作队等，2003），这进一步说明柱形的造型本身是多元化的。但是当代不存在这种情况，因为多数都是机械打磨，在规整程度上达到了相当好的程度。这一点我们在鉴定时应注意分辨。

鸡翅木串珠

缅甸花梨串珠

仿蜜蜡手串（筒珠）

缅甸花梨串珠

六、椭圆形

椭圆形的造型在串珠中最为常见。椭圆的造型比较符合视觉审美的习惯，特别是符合中国人的视觉习惯，手链、项链、挂件链、吊坠链等为常见，通常是视觉意义上的概念，以视觉为判断标准。来看一则实例，"六朝串饰，M6：21～25，呈椭圆形"（南京市博物馆，1998），看来不仅仅是管的造型，而且串珠的造型也常常是呈现椭圆形，椭圆的造型在串珠上俨然成为了一种风尚。再来看一则实例，"明代琥珀饰件，M1：10。体呈椭圆形"（南京市博物馆，1999）。由此可见，明代饰件也有椭圆形的，可见椭圆形的造型在琥珀上的应用进一步扩大化了。从做工上看，古代以手工制作，造型也是比较隽永，但是在规整程度的细节上显然是不如机械制作。当代串珠椭圆形的造型多数为机制，批量化特征较为明晰，但椭圆形也并非都是标准的椭圆形，有的时候写意的椭圆造型也常见。

金色珍珠

金色珍珠

优化绿松石梭形串珠

第二节　稀奇造型

一、纺轮形

纺轮形的造型在串珠上的应用有见。我们来看一则实例，西汉金串饰，M2：6，"纺轮状"（湖南省文物考古研究所等，2001）。这件实例中所谓纺轮形的造型都是一些串珠。将串珠制作成纺轮形其实很早就有见，新石器时代及商周时期的玛瑙极喜欢制作成纺轮形的造型。在当代，纺轮形的造型有一些变化，基本上变化成了隔珠的造型，应用特别广泛，成为各类串珠在组合当中不可缺少的造型。鉴定时应注意分辨。

二、梭　形

梭形的造型在串珠当中有见。两头小，中间大，这样的造型非常具有个性，各种艺术元素当中都在使用。我们来看一则实例，西汉金串饰，"梭形"（湖南省文物考古研究所等，2001）。由此可见，梭形的造型在西汉时期的金串饰之上就出现了。从质地上看，这种造型的珠子在玛瑙、琥珀、蜜蜡以及其他珠宝玉石上都有广泛应用，有的可能是梭形造型的变体，但仔细观察依然可以将其归入梭形的范畴。从时代上看，梭形的造型不同的时代都有见，当代也比较常见。

三、枣核形

枣核形的串珠有见。我们来看一则实例，汉代"珠的形状有枣核形、球形、灯笼形、管状、环状和极小的细珠"（云南省文物考古研究所等，2001）。由以上资料可见，汉代有见枣核形的造型。从数量

优化绿松石梭形串珠

金色珍珠

上看，枣核形的造型在时代特征上并不复杂，各个时代串珠当中只是有见，但应用并不广泛，直至当代都是这样。可见是一种较为稀有的造型，我们在鉴定时知道就可以了。

白珍珠

四、橄榄形

　　橄榄形的串珠有见。我们来看一则实例，春秋战国水晶管"橄榄形"（中国社会科学院考古研究所洛阳唐城队，2002）。橄榄的原产地在中国，是一种美味的水果，为我国人民所熟悉。因此，橄榄的造型在蜜蜡当中也是经常有见，并相当的流行。从形制上看，橄榄非常有形，两头小，中间大。由上可见，橄榄形的串珠造型在春秋已经有见，汉六朝隋唐辽金时期也有见，宋元明清时期更是常见，乃至民国及当代更是十分常见。从具体造型上看，常见项链、橄榄珠、手串、吊坠链、佛珠等。橄榄珠通常情况下比较大，造型隽永，雕刻凝练，分外美丽。但有的却是不太规整，与真正橄榄的造型有区别。看来，多数属于视觉意义上的橄榄造型，以视觉为判断标准。这一点我们在鉴定时应注意分辨。

钻孔绿松石串饰·新石器时代

绿松石串饰·新石器时代

南红凉山料算珠

南红凉山料算珠

五、纽扣形

纽扣形的串珠有见。我们来看一则实例，汉代水晶组合串饰"另2件为纽扣形"（广西壮族自治区文物工作队等，2003）。由上可见，纽扣形的造型在汉代水晶组合串饰上呈现了，这种较薄的如纽扣般的形状非常吸引人的眼球，所以在古代经常使用。但过小和薄的造型很少能够独立成器，一般情况下都是作为串珠的局部存在。从流行程度上看，各个时代都有见。从数量上看，各个时代基本相当，没有过于复杂性的特征。从总量上看，我们当代的数量可能多一些。从具体的造型上看，是视觉意义上的概念，以视觉为判断标准。

六、算珠形

算珠形的串珠最为有见。我们来看一则实例，汉代水晶组合串饰"1件为算珠形"（广西壮族自治区文物工作队等，2003）。可见，算珠形的造型在水晶串饰上呈现了。实际上，这种算盘珠形造型的出现远比算盘早，在商周时期就非常流行。如在河南三门峡西周大型邦国墓地虢国墓地当中就经常见到。一些大型的组合串饰之上的珠子造型多数都是算珠形。可见算珠形的造型十分古老。这种造型不仅是在西周时期有见，各个历史时期都有见，都是相当流行，直至我们当代。当然，在当代这种珠子作为隔珠的情况很多。从造型本身来看，算珠形的造型实际上也是视觉概念上的，以视觉为判断标准。从规整程度上看，古代手工珠子造型不太规整，仔细观察都能看到手工制作的痕迹；而当代机械制作比较标准，其造型规整，接近几何意义上的算珠形。这一点我们在鉴定时应注意分辨。

缅甸花梨手串

椰壳串珠

仿蜜蜡手串（算珠）

金丝玉手串

金沙石手串（三维复原色彩图）

七、半球形

半球形的串珠有见。我们来看一则实例，明代水晶珠"M3：36，体呈半球形"（南京市博物馆，1999）。可见，半球形的造型在水晶球体上呈现了。从造型本身来看，半球形的造型比较直观，基本上符合几何意义上的造型，只是在规整程度上，古代的有时略有问题，在当代机器制作当中，这个问题已经不成为问题了，大多数造型规整。当然半球性的造型在串珠上的应用比较广泛，如手串、项链等都有见。从时代上看，各个时代都有见，在比例上较为均衡，但显然在历史上并不是特别的流行。

小叶紫檀串珠

香樟木手串

第三章　串珠鉴定

第一节　新石器时代串珠

　　新石器时代串珠有见。我们来看一则实例，"玛瑙珠47粒。95TZM134：1，用红色玛瑙石磨制而成，圆形。直径0.7厘米、厚0.35厘米、中间孔径0.1厘米"（青海省文物管理处等，1998）。可见，新石器时代串珠已经是比较流行。依据此例看，中间有孔，可以穿系成手链、项链等各种各样的造型。从质地上看，新石器时代串珠的质地比较多，如绿松石、软玉、骨质、岫玉、石质等都有见。我们来看一则实例，"绿松石珠146粒。多与骨珠相间串成链饰。95TZM216：1，圆柱形。长1.5厘米、直径0.8厘米、中间穿孔径0.25厘米"（青海省文物管理处等，1998）。从打磨上看，新石器时代串珠在打磨上前期不是很好，但是在中后期打磨得相当漂亮，与历史上各个时期的串珠等没有太大的区别。从数量上看，新石器时代串珠数量并不是太多，但由于新石器时代时间比较长，珠宝种类众多，所以在总量上有一定的量。

绿松石串珠·新石器时代

玉串珠·新石器时代

　　总而言之，串珠早在新石器时代已经出现，其中在内蒙古兴隆洼文化遗址的一座墓葬中发现了两件精美的玉玦，是迄今我国发现最早的玉器之一（王玉哲，1990）。该遗址距今 8000～7000 年。而距今 7000 年左右的浙江余姚河姆渡遗址第三、四层也出土了管、珠、璜、玦等玉器。玛瑙更是在旧石器时代便有使用。距今 5500～5000年的红山文化将古代玉器发展到顶峰，但红山文化中的璜、玦、管、珠等玉器，从形制和出土位置看，主要用途还是装饰。太湖流域的马家浜文化也有玦、璜、管等器物。继马家浜文化之后的崧泽文化同样有出土，但从其质量看，明显不如红山文化。但继崧泽文化发展而起的良渚文化与红山文化并驾齐驱，使中国石器时代玉器发展到了最高峰。良渚文化的主要器形包括玦、璜、管、珠等发饰的单件。但良渚文化的璜已经脱出了原始的美感及装饰的意义，走上了与原始宗教、自然崇拜、图腾崇拜相结合的道路，被蒙上了神秘的面纱，逐步离开现实生活，走上了神圣的祭坛，成为神秘礼器的一种。可见串珠在新石器时代实际上已经是较为发达，其共同组合而成的器物具有玉礼器的意味。

绿松石串珠·新石器时代

七璜组合玉佩（旋转图）·西周

第二节 夏商西周串珠

夏代串珠依然延续前代，变化不大，主要以简单器物造型、简单串联方式等为主。总之创新并不多，我们就不再过多赘述。商代和西周时期串珠已经是比较复杂，从质地上看，已经表现出各种材质相互组合成器的趋势；从串联方式上看相当复杂，出现了一些大型组合玉佩，以串珠的方式组合在一起。我们具体来看一下。

一、组佩饰

组佩饰为重要礼器造型，是由两件（颗）以上玉器通过串联方式组合成的一组具有某种特定功能的玉质装饰品。然而，玉器中数量最多的就是装饰品。组佩饰主要有以下几种：玛瑙珠、玉管、环组合，佩、璜组合，玛瑙珠、玉佩组合，璜连珠组合，玉管、佩组合，玛瑙珠与绿松石组合。其中大型组合玉佩主要流行于西周晚期和春秋早期，如虢国墓地和晋侯墓地都出土有组合异常发展的大型组合玉饰。其中以虢国墓地出土的一件七璜联珠组玉佩最为大型。七璜联珠组玉佩出土于 M2001 号国君大墓，共由 374 件（颗）的器物组成，整个组玉佩分为上下两部分：上部为玛瑙珠、玉管组合项饰；下部用玉璜、玛瑙珠和料珠组合。上部由 122 件（颗）组成：1 件人龙合纹玉佩、18 件玉管、103 颗红玛瑙珠。其中，14 件长方形玉管两两并排地分别串联在两行玛瑙珠之间，另外 4 件呈现单行串联于其间。后者显然是为了避免两行串珠分离而起约束作用。玉佩位于墓主人颈后中部，为项饰的枢纽，展开长度约为 53 厘米，出土于墓主人的颈部。下部共计 252 件（颗）。由七件玉璜由小到大与纵向排成双排四行对称的 20 件圆形玛瑙管、117 颗玛瑙管形珠、108 颗菱形

七璜联珠组合玉佩·西周

虢国玉组佩·春秋早期

料珠相间串联而成。20 件玛瑙管分为 10 组，每 2 件成一组。料珠为 18 组，每组为 6 颗。玛瑙珠分为 16 组，为 2 颗、4 颗、13 颗不等为一组，统一作并排两行，以青白色玉璜为主色调，兼以红、蓝二色，出土于墓主人胸及腹部（河南省考古研究所等，1999）。但此类组合玉佩很少，目前发现的仅仅只有几件。所以，市场上出现的大多都是伪品，收藏者应该谨慎购买，从玉管、玛瑙珠、料珠上来鉴定。七璜玉组佩上有 18 件玉管，为和田青玉，微透明，分为圆、扁圆、扁方形三种，器物表面以龙纹为主，间以斜三角纹、圆形、涡纹，虽为玉管但玉料选择考究，纹饰多样，做工精细，均属上乘之作。其分布位置全部集中于七璜组玉佩的上半部，下半部为玉璜、玛瑙珠、料珠组合，但五璜组玉佩上没有玉管，其组合器物和七璜组玉佩下半部相同。这可能是由于等级的不同。玛瑙珠是组玉佩中最多的组合器物，大都呈红色或橘红色，有规律的相互串联。料珠是仅次于玛瑙珠的组合器物，两端有穿孔，或长或短，或粗或细，呈菱形，浅蓝色，表面有光泽，除七璜组玉佩上部无分布外，其余部位均有分布。玉管、玛瑙珠、料珠是组成玉组佩的主要器物，但它们不是主体，而是为了突出璜。因为从七璜和五璜玉组佩来看，这三种器物无太明显的规律，特别是玛瑙珠和料管，而且玛瑙珠和玉管来源较广，属西周时期常见器物，未发现有象征权力和地位的迹象。因此，玉管、玛瑙珠、料珠在璜联珠组玉佩中的功能应为连接与装饰。但组玉佩本身来讲是重要的礼器。如国君可以佩戴的是七璜组玉佩，国君夫人佩戴的是五璜组玉佩，这与天子九鼎八簋八鬲、诸侯七鼎六簋六鬲、大夫五鼎四簋四鬲的规制是相匹配的。这一点我们在鉴定时应注意分辨。

二、组合发饰

　　为重要的玉礼器造型。即大型的组合异常复杂的发饰，可分为玛瑙珠、玉管、环组合和佩、璜、玦组合两种。玛瑙珠、玉管、环组合发饰出土于墓主人头部右上方，由衔尾双龙纹玉环、素面玉环、玉管、玉珠、牛首形玉佩、大小红色玛瑙珠与石贝等分作两行相间串联组成。其中衔尾双龙纹玉环串联于发饰首末两端的结合处，为本组发饰的枢纽。4件小环分置于首末两端。大颗玛瑙珠分双行并排串联，且被八件玉管相间分成六组，每组 6～8 颗不等。而十颗玉珠则专门是用于打结的。佩、璜、玦组合发饰也出土于墓主人脑后，共有 17 件器物组成：鹰形佩 1 件、鹦鹉形璜 1 件、虎形璜 1 件、大玦 2 件、中玦 2 件、小玦 2 件、弦纹管 1 件、小玛瑙珠 7 颗，其中，2 个大玦与 2 件玉璜及凹弦纹管并行排列，凹弦纹管下垂直排列着 2 件中玦与小玦。鹰形佩垂直其下，另外两件中、小玉玦又垂直在鹰形佩之下，7 颗小玛瑙珠分别附于鹦鹉形玉璜两端穿孔处，组成了一件酷似鹰形的发饰（河南省考古研究所等，1999）。组合发饰出现得很少，以上均是河南三门峡虢国墓地出土的组合发饰，其流行年代也基本上是西周晚期。该发饰形态逼真、造型隽永、雕刻凝练，鹰的身体比例掌握得十分恰当，使人感觉到雄鹰在蓝天上飞翔，俯视着大地，威武雄壮之极，确系罕见的稀世珍宝。从这件发饰组件可以看出，制作者对鹰的观察已是深入胎骨，在鹰形发饰上艺术

玛瑙珠、玉管组合饰件·西周

玛瑙珠、玉管组合发饰·西周

鹰、璜、玦组合发饰·西周　　　　　　　　　鹰、璜、玦组合发饰（侧面）·西周

地应用了间接、隐讳、寓意、表征的手法，结合形象、联想，进而诉诸视觉，充分地利用抽象、意似、表象、变形等艺术表现手法来刻画鹰之形象，甚至还注意到了人的心理。我们知道感觉和知觉是人们认识的初级阶段，人们为了认识事物，借助记忆过去生活实践感知过的东西，在大脑中重复反映出来，这是一个复杂的认识过程，起净化作用。也就是说人们对事物的认识过程，不仅是通过感知去认识事物的外在联系，同时还会以表象的形式向思维过渡，进一步认识事物的一般特性和内在联系，进而全面本质地把握事物的本质。这个思维过程是人们对客观事物在头脑中概括的、间接的反映，是人类认识的高级阶段，即理性认识阶段。那么当时制作这件鹰形佩的人对鹰的认识也应该是这样一个过程。这是人类思维发展的共同规律，它不受时代上的限制。然而，虽然人类认识事物的客观规律不会改变，但是玉工匠在具体制作这件鹰形发饰时却要受到时代的限制，因为发饰历来都是显示身份的标志。红山文化马蹄状玉箍多见于中心大墓，如牛3MT，牛16M1等，但也有的中心大墓不见（郭大顺，1997），如胡头沟M1，推测该类玉箍并非最高等级墓葬所必备，而是具有一定的普遍性。这一风俗流传到虢国，并得到了发展，发饰象征等级与地位的功能发展到了极致，即"礼"的功能得到了升华。在虢国，发饰由玉箍发展到了组合发饰，而且非一般贵族可以享用，可见地位之高，且非一般礼器可与之相比较，因为仅限于国君墓使用。本书作者认为组合发饰可能为王权的象征，只有周王及国君可以使用，其余诸如国君夫人、太子均不达级别。

　　由以上二例可见，西周时期在礼器的作用下，工匠们对于串珠的制作可谓是精益求精，一丝不苟，不计工本，无论在功能、用料、工艺、串联方式等特征上，无疑都达到了相当的水平，直至今日，几无超越者。

玛瑙珠、玉管组合发饰·西周

和田青玉管、红玛瑙组合·西周

第三节 春秋战国串珠

　　大型组玉佩在春秋战国时期继续发展，达到鼎盛。有关文献记载关于组玉佩的内容很多，如《周礼·天宫冢宰·王府》："佩玉上有葱衡，下有双璜，冲牙，珍珠以纳其间"。《大戴礼·保傅》载："上有双衡，下有双璜、冲牙、蚳珠以纳其间。"可见战国组玉佩的兴盛。虽然达到全盛，但大型玉组佩礼的功能却下降了，因为春秋战国时期由于礼制崩溃，周礼再无人遵守，串珠不再与玉礼器相联系，而是主要转向大众化的陈设装饰之美。在这样的环境下，大型组玉佩的地位也是日渐下降。但由于该类型的玉佩制作十分复杂，且费工费料，在春秋战国以至于以后，也还是较为珍贵的，多为诸侯级别的奢侈品。由此可见，在东周时期这个风云变幻的时代，权力由上天的神受观念重新彻底地回到了人间，被春秋、战国时代国与国之间

玉项饰·春秋

的实力所替代，那么，标志着"神权"时代权力与地位的玉礼器，自
然就退出了历史舞台。从此，玉礼器所有的神力几乎全无，即使有也
很微弱。在失去礼制作用下的春秋战国时期，串珠回归到了项链、手
串等传统造型之上。我们来看一则实例，"玉珠1件（M32：4）。扁鼓
形，通体磨光。呈淡绿色，中间有一圆形穿孔。直径4.1厘米、厚1.1
厘米、孔径0.9厘米"（湖北省文物考古研究所，2000）。可见，在
造型上与西周的繁复相比有一个很大程度上的回归。鉴定时应注意
分辨。

<div align="right">玉项饰·春秋早期</div>

<div align="right">玉组佩·春秋早期</div>

战国红标本

第四节 汉唐串珠

汉唐串珠的质地多数较好，以白玉为多，多为灰白色玉。较好的软玉制品产自新疆，也有其他地方的一些软玉制品，但数量很少。另外，汉唐时期十分讲究玉器的广义性概念，正如汉代许慎《说文解字》称玉为"石之美有五德"，所谓五德即指玉的五个特征，凡具温润、坚硬、细腻、绚丽、透明的美石，都被认为是玉。由此可见，汉代对于古玉器概念的宽泛。同样，唐代也是这样，实际上许慎的这段话就是汉唐玉器在玉质上的生动写照。通常来讲，除了玉之外，还有美石、玛瑙、绿松石、琥珀、水晶、琉璃、料珠等都被纳入玉器的范畴。我们来看一则实例，组合串饰5组……M5：67，摆放在头部的左侧，包括1件水晶，白色，六角长条形；玛瑙2件，红色，1件算珠形，1件橄榄形；琉璃珠20件，扁圆形，较小"（广西壮族自治区文物工作队等，2003）。可见，串珠之丰富、造型之多，力求达到最精美。同时也可以看到，这些不同质地的珠宝在汉代显然是被纳入玉器的范畴，因为它们符合玉之五德的概念。

优化和田白玉籽料标本

优化绿松石环形珠

玉雕鸳鸯炉·唐代

　　同样，琥珀在唐代也非常流行，我们来看一组实例，"玛瑙珠1枚（M1：6）。棕色带褐黄色，半透明。管状，中间稍粗，穿细孔，表面略微磨光，加工不精。直径0.6～0.7厘米、长1.2厘米、孔径0.1厘米。螺串饰2枚。M1：7，已残，仍可辨识。白色，以小螺壳磨孔而成，可能与玛瑙珠同为一串。长1.2厘米、径0.8厘米"（中国社会科学院考古研究等，1998）。由此可见，在唐代玛瑙同样流行，人们将玛瑙制成各种各样的装饰品，或者作为大型串饰的组件供串系之用，而上面的玛瑙珠就是这样一种用途。另外，从第二个实例来看，我们可以看到在唐代螺壳也被当成了玉器，螺壳和玛瑙珠共同组合成为串饰，这在我们现在是不可思议的事情，但在汉唐时代就是这样。虽然这使我们在思想上有一些震动，但是我们不能回避它。

　　总之，由上可见，汉唐时期串珠同我们当代一样是人们钟爱的装饰品。

琥珀标本

红水晶标本

第五节　辽金宋元时期串珠

辽金宋元时期串珠也是相当流行。

我们来看一则实例，"玛瑙管，五代、辽，红色原柱形管，表面抛光，两头孔对穿，长短、粗细不同。长 1.7 ～ 8.3 厘米、管径 0.5 ～ 0.9 厘米，孔径 0.2 ～ 0.3 厘米"（内蒙古考古所，1996）。耶律羽之生于唐代大顺年间，为耶律阿宝机所器重，后为上柱国和太师等职。所以，耶律羽之墓葬当中随葬的器物多有唐五代和辽的特征，这也是跨时代的人的墓葬中器物所具有的共同特征。玛瑙珠这种传统的器物在新石器时代就已经开始使用，一直到后来，在西周时期用玛瑙珠制作的大量的串饰。而在该墓葬中出土玛瑙珠，说明在五代和辽代时期还延续着用玛瑙珠作为串饰的古老传统。

我们从陈国公主墓葬当中，可以看到玛瑙珠串联的方法，玛瑙串饰，"玛瑙管与水晶球间隔，加上鸡心形金坠及管状金坠组成"。玛瑙臂饰的串联是以"玛瑙管与镂空金球组成，以上佩饰均以丝线串系"。看来在辽代玛瑙珠的地位和以前没有多大的区别，都是与高贵质地的材料一起组串成器。在西周时期玛瑙珠总是与玉佩组串，小到手链，大到大型玉组佩都是这样；而到了辽代与之相连的器物发生了改变，不是玉器而是精美的金器。看来，在五代和辽代时期，金器的地位不断上升，代替了玉器的地位。从此将中国以玉器为主的时代结束了，取而代之的是一个以金器为主的时代。而这件器物就是玉器在辽代地位下降的一个实证，同时也是唐代玉金结合器在辽代的一个延续。

宋元时期串珠基本是延续前代，主要延续了唐五代辽金时期的一些特点，很少见有创新，我们就不再赘述了。鉴定时应注意分辨。

第六节 明清串珠

明清时期串珠基本上延续前代，但与西周时期相比保留下来的是一些较为简单的串饰，如朝珠。朝珠也是由不同质地的器物在一起共同组合而成。我们来看一则实例，"清代朝珠 M4∶1，100 粒木珠，光滑黑亮，4 粒翡翠佛头，其中一粒饰佛头塔；每串 10 粒。佛头直径 2.3 厘米、木珠直径 1.4 厘米、周长 128 厘米"（苏州博物馆，2003）。由此可见，这件朝珠的组合也是相当复杂，从组合器物上看，主要有木珠、佛头、佛头塔等。从质地上看，主要有木、翡翠等。这可能是清代较为复杂的组合串饰了，不过这类串饰比起礼器时代的玉组佩，其串联方式和所使用的材料可是逊色多了。另外，在明清时代还有一些比朝珠的串联要简单的玉串饰，如一些佛珠等。由上可见，明清时期大型串饰比例太少了，串联方式也多是较为简单。不过，有向材质化发展的趋势，如金串饰在当时就比较流行。

金串饰·明代

金串饰·明代

金串饰·明代

金串饰·明代

　　明清时期的串饰有向小型化发展的趋势，我们发现明清时期有将玉饰，如玉鱼、玉鸟等玉佩，以及玉管、玉环等器物用玉珠分开，丝线串联起来的小型串饰，美其名曰杂宝串或多宝器。串联方式多种多样，有的简单，有的复杂，也有很多的定式。这些小型的玉串饰有一个共同的特点，就是玉质优良、造型隽永、雕刻凝练，多是精绝之器，等于说是将多件玉器串联起来使用。这些小型玉串饰的功能应该不是一种佩戴在人身上的玉饰。因为这些串联的玉饰相互碰撞，很有可能会碎掉，但也不排除在特殊的场合佩带。不过，相信一般情况下都是悬挂在某处，供人们欣赏，实际上应该是一种观赏性的陈设品。

　　另外，我们还发现，玉串饰在明清时期还有许多种类型。如将玉珠串联在一起成为手链，这样的串饰在明清时期很时兴。我们在不

少地方都发现了这类手链，有的是白玉连珠、有的是玛瑙连珠。一般选用的玉质都较好，玉链子看起来很漂亮。另外，这些串联的链子在造型上也不限于珠子，也有成正方形或者长方形的，有的甚至是将不规则体的造型串联在一起，我们也可以叫做链子吧！有时在这些不同的片状造型之上还常常刻画有纹饰和文字，图案多以吉祥如意及人们喜闻乐见的图案为主要特征，如花卉、生肖等图案都非常流行。在玉质和做工上，这些串联而成的玉链都是非常之好，多为精绝之作。

总之，明清串珠已经普及化了，在质地上已经突破了宝石、玉石、有机宝石的范畴，如黄花梨串珠、沉香串珠等，帝王将相、平民百姓都有在使用，是人们精神风貌的外化。

金串饰·明代

金串饰·明代

翡翠手串

第七节　当代串珠

当代串珠除了在组合方式上自然，没有礼制的约束外，在诸多方面较之前代有着相当程度的超越。

从质地上看，当代串珠在质地上是以往任何一个时代都不能比拟的。如珊瑚、猫眼、碧玺、托帕石、橄榄石、海蓝宝石、祖母绿、磷铝锂石、锂辉石、矽线石、翡翠、和田玉、白欧泊、黑欧泊、火欧泊、寿山石、田黄、青田石、水镁石、苏纪石、异极矿、锂云母、玛瑙、黄龙玉、蓝玉髓、绿玉髓（澳玉）、虎睛石、鹰眼石、石英岩、水钙铝榴石、硅硼钙石、羟硅硼钙石、方钠石、赤铁矿、天然玻璃、黑曜岩、玻璃陨石、鸡血石、针钠钙石、绿泥石、东陵石、岫玉、独山玉、查罗石、钠长石玉、蔷薇辉石、阳起石、绿松石、青金石、孔雀石、硅孔雀石、葡萄石、大理石、汉白玉、白云石、蓝田玉、菱锌矿、菱锰矿、萤石、珍珠、蜜蜡、血珀、金珀、绿珀、蓝珀、虫珀、植物珀、煤精、象牙、玳瑁、砗磲、硅化木等都有见，可见种类之丰富。

多宝串

鸡翅木串珠

当然，这些珠宝当中有的可能作为串珠并不是它的最佳表现形式，如绿泥石、大理石等，但的确是有见。可见当代人们对于串珠进行了多种材质的尝试，但是对于大多数材质，串珠都是其重要的造型，如琥珀、蜜蜡、和田玉、黄龙玉、玛瑙、砗磲、珊瑚等。

从数量上看，当代串珠可谓是众多，达到了历史之最。在当代，我们到珠宝市场里首先看到的可能就是琳琅满目的串珠。

从工艺上看，古代主要是手工制作，可以说在每一个珠子上都会留下手工的痕迹；但当代主要是以机械制作为主，大多数都可以达到相当标准的圆形或者其他串珠的造型，可见在规整程度上之优，只是程式化的特征略有显现。

从造型上看，当代串珠基本上没有超越古代串珠的造型，主要以手串、项链、佛珠、挂链等为多见，其他的造型比较少见。鉴定时应注意分辨。

和田青玉手串

战国红玛瑙算珠

孔雀石手串

天河石单珠

虎睛石串珠

血珀串珠

仿花珀手串

蜜蜡串珠

砗磲手串

青金石串珠

芙蓉石手串

第四章　识市场

第一节　逛市场

一、国有文物商店

　　国有文物商店收藏的串珠具有其他艺术品销售实体所不具备的优势。一是实力雄厚；二是古代串珠数量较多；三是中高级专业鉴定人员多；四是在进货渠道上层层把关；五是国有企业集体定价，价格不会太离谱。国有文物商店是我们购买串珠的好去处。基本上每一个省都有国有的文物商店，分布较为均衡。下面我们具体来看一下国有文物商店串珠品质状况。

鸡翅木串珠

柯檀手串

缅甸花梨串珠

<h2 align="center">国有文物商店串珠品质状况</h2>

名称	时代	品种	数量	品质	体积	检测	市场
串珠	高古	极少	极少	优／普	小器为主	通常无	国有文物商店
	明清	稀少	少见	优／普	小器为主	通常无	
	民国	稀少	少见	优／普	小器为主	通常无	
	当代	多	多	优／普	大小兼备	有／无	

翡翠手串

玛瑙珠（三维复原色彩图）·西周

　　由上可见，从时代上看，串珠古代有见，如绿松石、煤精、珊瑚串珠、陶串珠等在新石器时代就有见，和田玉、玛瑙等在商周时期已是非常流行，我们来看一则实例，"玛瑙珠分为16组，为2颗、4颗、13颗不等为一组，统一作并排两行，以青白色玉璜为主色调，兼以红、蓝二色，出土于墓主人胸及腹部"（河南省考古研究所等，1999），秦汉以降，直至当代串珠都是非常的流行。但这些串珠多是随葬在墓穴当中，多数经过科学发掘出土，都保存在博物馆中，所以即使国有的文物商店数量也很少，并以明清民国时期的串珠为主。这是因为明清民国时期的串珠主要是传世品，所以比较常见。当代串珠达到了鼎盛，各种各样的串珠都有见。

金丝玉手串

小叶紫檀串珠

石榴石串珠

　　从品种上看，高古串珠品种没有当代齐全，如陶串珠、骨串珠、牙串珠、金串珠、玉串珠等都有见，直至明清民国时期都是这样。明清民国时期串珠在材质品种上数量逐渐多了起来，如黄花梨、紫檀、红酸枝串珠等都比较常见。当代串珠材质在品种上集以往之大成，如陶串珠、骨串珠、牙串珠、金串珠、银串珠、瓷串珠、沉香串珠、沉香木串珠、铜串珠、角串珠、竹串珠、金刚菩提串珠、核桃串珠、猫眼串珠、变石串珠、变石猫眼串珠、空晶石串珠、矽线石串珠、橄榄石串珠、石榴石串珠、镁铝榴石串珠、铁铝榴石串珠、锰铝榴石串珠、钙铬榴石串珠、钙铝榴石串珠、翠榴石串珠、黑榴石串

香樟木手串

黄花梨串珠

孔雀石手串

虎睛石串珠

黄金楠手串

珠、钙铁榴石串珠、水晶串珠、月光石串珠、蓝晶石串珠、天青石串珠、冰洲石串珠、斧石串珠、锡石串珠、磷铝锂石串珠、透视石串珠、蓝柱石串珠、磷铝钠石串珠、赛黄晶串珠、金丝楠串珠、绿檀串珠、黄金楠串珠、猫眼紫檀串珠、缅甸花梨串珠、柯檀串珠、花奇楠串珠、玫瑰金丝楠串珠、非洲花梨串珠、黑檀串珠、桃木串珠、血檀串珠、朱砂串珠、崖柏串珠、红酸枝串珠、黄花梨串珠、翡翠串珠、和田玉串珠、白欧泊串珠、黑欧泊串珠、火欧泊串珠、玉髓串珠、玛瑙串珠、黄龙玉串珠、蓝玉髓串珠、绿玉髓串珠、青金石串珠、孔雀石串珠、硅孔雀石串珠、葡萄石串珠、汉白玉串珠、蓝田玉串珠、菱锌矿串珠、菱锰矿串珠、虎睛石串珠、鹰眼石串珠、东陵石串珠、水镁石串珠、苏纪石串珠、异极矿串珠、云母串珠、白云母串珠、锂云母串珠、针钠钙石串珠、绿泥石串珠、白云石串珠、萤石串珠、岫玉串珠、独山玉串珠、查罗石串珠、钠长石玉串珠、蔷薇辉石串珠、阳起石串珠、绿松石串珠、鸡血石串珠、田黄串珠、青田石串珠、水钙铝榴石串珠、珍珠串珠、珊瑚串珠、琥珀串珠、硅化木串珠、龟甲串珠、砗磲串珠、煤精串珠、象牙串珠等都有见。

血珀串珠

柯檀串珠

蜜蜡串珠

芙蓉石手串

　　从数量上看，国有文物商店内的串珠以古代为主，但数量比较少见；当代串珠在数量上相对于古代串珠较多，但相对于其他市场来讲并不算多。因为文物商店并不是主要销售串珠的地方。

　　从品质上看，古代串珠在品质上较为优良，但普通的品质也是常见；当代串珠基本上以优良为主，普通者只是有见。

　　从体积上看，国有文物商店内的串珠以小件为主，大件并不常见，形制单一；当代串珠则是大小兼备，各种型号的都有见。

　　从检测上看，古代串珠通常没有检测证书等，明清和民国都是这样；而当代串珠一般都有检测证书，真伪问题迎刃而解，但优劣还需自己判断。

仿蜜蜡手串（圆珠）

二、大中型古玩市场

大中型古玩市场是串珠销售的主战场。如北京的琉璃厂、潘家园等，以及郑州古玩城、兰州古玩城、武汉古玩城等都属于比较大的古玩市场，集中了很多串珠销售商。像北京的报国寺只能算作是中型的古玩市场。下面我们具体来看一下大中型古玩市场串珠品质状况。

大中型古玩市场串珠品质状况

名称	时代	品种	数量	品质	体积	检测	市场
串珠	高古	极少	极少	优／普	小器为主	通常无	大中型古玩市场
	明清	稀少	少见	优／普	小器为主	通常无	
	民国	稀少	少见	优／普	小器为主	通常无	
	当代	多	多	优／普	大小兼备	有／无	

酸枝手串

酸枝手串

黑曜石串珠

由上可见，从时代上看，大中型古玩市场的串珠高古、明清、民国和当代都有见，只是古董串珠比较稀少，而当代串珠数量比较多而已。从品种上看，串珠在古代比较单一，主要是各色玛瑙、各色玉器、金银串珠等为多见；当代串珠的种类较多，几乎囊括了上百种，达到了历史之最，也可见当代盛世之况。从数量上看，高古串珠在大型古玩市场内出现的数量极少，而在明清及民国时期基本上是有见。当代大中型市场内的串珠比较多，许多都是带有批发性质的门店，要多少有多少。从品质上看，串珠在品质上无论是古代还是当代，基本上都是以优良为主，但是普通者也有见；在当代粗糙者也有见。从体积上看，大中型市场内的串珠高古以小件为主，很少见到大器；而明清、民国的串珠则在体积上略大一些；当代则是大小兼备，串珠的型号多者可以达到数十种。从检测上看，古代串珠进行检测的很少见，而当代串珠基本上也是这种情况，特别贵重的串珠有检测证书。

黄金木串珠

柯檀串珠

鸡翅木串珠

金刚菩提串珠

酸枝串珠

椰壳串珠

缅甸花梨手串

三、自发形成的古玩市场

这类市场三五户成群，大一点的几十户。这类市场不很稳定，有时不停地换地方，但却是我们购买串珠的好去处。我们具体来看一下自发古玩市场串珠品质状况。

自发古玩市场串珠品质状况

名称	时代	品种	数量	品质	体积	检测	市场
串珠	高古						自发古玩市场
	明清	稀少	少见	优／普	小器为主	通常无	
	民国	稀少	少见	优／普	小器为主	通常无	
	当代	多	多	优／普	大小兼备	通常无	

酸枝念珠

缅甸花梨手串

柯檀手串（三维复原色彩图）　　翡翠带绿和田玉珠（三维复原色彩图）　　绿檀手串（三维复原色彩图）

　　由上可见，从时代上看，自发形成的古玩市场上的串珠明清时期有见，但高古串珠很少见，即使有见，但真货如大海捞针一般稀少。这类市场主要还是以销售当代串珠为多见。从品种上看，自发形成的古玩市场上的各类串珠古代的不多见，当代的不论真伪，各种各样质地的基本上都能找到。但真伪全凭自己判断。从数量上看，古代串珠很少见，以当代为主，总量相当大。从品质上看，古代串珠以优质和普通者为多见，当代基本延续这一传统。从体积上看，古代串珠基本以小器为主，当代则是大小兼备。从检测上看，这类自发形成的小市场上串珠基本上没有检测证书，全靠眼力。

酸枝手串

酸枝手串

顺化沉香珠（三维复原色彩图）·越南

青金石串珠

孔雀石手串

四、大型商场

大型商场内也是串珠销售的好地方。因为串珠本身就是奢侈品，同大型商场血脉相连。大型商场内的串珠琳琅满目，各种各样，应有尽有，在串珠市场上占据着主要位置，我们具体来看一下大型商场串珠品质状况。

大型商场串珠品质状况

名称	时代	品种	数量	品质	体积	检测	市场
串珠	高古						大型商场
	当代	多	多	优／普	大小兼备	通常无	

茶晶串珠

缅甸花梨珠（鸟足紫檀）（三维复原色彩图）

蜜蜡单珠与唐三彩碟组合（三维复原色彩图）

　　由上可见，从时代上看，大型商场内的串珠以当代为主，古代基本没有。从品种上看，大型商场内串珠的种类非常多，但有重点，多数是人们比较熟悉的品种，如南红串珠、水晶串珠、翡翠串珠、白玉串珠、珊瑚串珠、金串珠、银串珠、黄花梨串珠、紫檀串珠等。从数量上看，各类串珠都非常多，这与当代科技的发达，各种资源被大量开采有关。从品质上看，大型商场内的串珠在品质上以优质为主，普通者有见，总体上品质比较好，向高档化发展。从体积上看，大型商场内串珠大小兼备，如和田玉的新疆料串珠主要是以小为主，包括一些料子比较好的沉香串珠等，也是以小料为主；而水晶、黄龙玉、玉髓等多是以大件为主。从检测上看，大型商场内的串珠由于比较精致，较为贵重，多数有检测证书。

莫莫红珊瑚珠（三维复原色彩图）

蜜蜡串珠

小叶紫檀串珠

钧瓷玫瑰紫釉串珠（三维复原色彩图）

小叶紫檀串珠

南红凉山料手链

五、大型展会

大型展会，如串珠订货会、工艺品展会、文博会等成为串珠销售的新市场，我们具体来看一下大型展会串珠品质状况。

大型展会串珠品质状况

名称	时代	品种	数量	品质	体积	检测	市场
串珠	高古						大型展会
	明清	稀少	少见	优／普	小器为主	通常无	
	民国	稀少	少见	优／普	小器为主	通常无	
	当代	多	多	优／普／劣	大小兼备	通常无	

红水晶串珠（三维复原色彩图）

酸枝手串

　　由上可见，从时代上看，大型展会上的串珠明清、民国有见，但数量很少，而以当代为主。从品种上看，大型展会上串珠材质比较多，已知的串珠材质基本在展会上都能找到。从数量上看，各种串珠琳琅满目，数量很多，各个批发的摊位上可以看到成麻袋的串珠等。从品质上看，大型展会上的串珠在品质上可谓是优良者有见，更有见普通者，低等级的串珠也有见。从体积上看，大型展会上的串珠在体积上大小都有见，体积已不是串珠价格高低的标志，主要以品质为判断标准。从检测上看，大型展会上的串珠多数无检测报告，只有少数有检测报告，但也只能是证明是该材质，其优良程度则是无法判断，主要还是依靠人工来进行辨别。

小叶紫檀手串

多宝串

和田青玉手串

柯檀串珠

鸡翅木串珠

缅甸花梨珠（鸟足紫檀）（三维复原色彩图）

六、网上淘宝

网上购物近些年来成为时尚，同样网上也可以购买串珠。上网搜索，会出现许多销售串珠的网站。下面我们来具体看一下网络市场串珠品质状况。

缅甸花梨手串

网络市场串珠品质状况

名称	时代	品种	数量	品质	体积	检测	市场
串珠	高古	极少	极少	优／普	小	通常无	网络市场
	明清	稀少	少见	优／普／劣	小器为主	通常无	
	民国	稀少	少见	优／普／劣	小器为主	通常无	
	当代	多	多	优／普	大小兼备	有／无	

　　由上可见，从时代上看，网上淘宝可以很便捷地买到各个时代的串珠，随意搜索时代名称加串珠即可。但是，通常情况下明清、民国时期只是有见，不过数量很少；明清以前的很少见；以当代为常见。从品种上看，串珠的品种极全，几乎囊括所有的串珠品类。如和田玉串珠、翡翠串珠、琥珀串珠、蜜蜡串珠、珊瑚串珠、金丝楠串珠、绿檀串珠、黄金楠串珠、猫眼紫檀串珠、缅甸花梨串珠、柯檀串珠、花奇楠串珠、玫瑰金丝楠串珠、非洲花梨串珠、黑檀串珠、桃木串珠、血檀串珠、朱砂串珠、崖柏串珠、红酸枝串珠、黄花梨串珠等。从数量上看，各种串珠的数量也是应有尽有。从品质上看，高古以优良和普通为主；明清、民国时期则是优良、普通、粗劣者都有见；当代则是以优良和普通为多见。这说明，当代串珠在质量上有了飞跃。但网上购物一定要先辨明真伪。从体积上看，古代串珠绝对是

南红凉山料手链

黄金木串珠

青金石串珠（三维复原色彩图）

黄晶珠（三维复原色彩图）

小器，且型号较为单一；明清和民国时期基本上也是这样；当代串珠大小兼备，各种各样大小的串珠都有见，适合儿童、大人等各种人群。从检测上看，网上淘宝而来的串珠大多没有检测证书，只有一部分有检测证书。当然，在选择购买时最好是选择有证书者。但证书只是其物理性质的描述，并不能对品质进行有效的判断，这一点我们在购买时应注意分辨。

柯檀串珠

香樟木手串

血檀串珠

顺化沉香珠（三维复原色彩图）·越南

金丝竹手串

香樟木手串

七、拍卖行

串珠拍卖是拍卖行传统的业务之一。因此，拍卖行是我们淘宝的好地方。下面具体我们来看一下拍卖行串珠品质状况。

拍卖行串珠品质状况

名称	时代	品种	数量	品质	体积	检测	市场
串珠	高古	极少	极少	优／普	小	通常无	拍卖行
	明清	稀少	少见	优良	小器为主	通常无	
	民国	稀少	少见	优良	小器为主	通常无	
	当代	多	多	优	大小兼备	通常无	

小叶紫檀串珠与太行崖柏老房梁

　　由上可见，从时代上看，拍卖行拍卖的串珠各个历史时期的都有见，但以明清和民国及当代串珠为主。从品种上看，拍卖市场上的串珠在品种上比较齐全，但拍卖的串珠有一个特点，基本上以名品为主。如珊瑚串珠、黄花梨串珠、紫檀串珠、翡翠串珠、和田玉串珠等为多见。基本上是只有在达到一定起拍价的基础上才会拍卖，这是由拍卖行的盈利方式所决定。因为拍卖行是佣金制，所以如果拍卖的价格都很低，自然是不行的。从数量上看，高古串珠极少见有拍卖，而明清、民国时期已经是比较多见，但是相对于当代还是属于绝对的少数。从品质上看，高古串珠优良者有见，普通质地也有见，如陶串珠等，质地就很普通，但其拥有极高的文物价值，也有很高的经济价值；而明清、民国时期的串珠主要是以优良质地为主，当代串珠品质特征基本延续传统。从体积上看，高古串珠在拍卖行出现也是无大器；明清、民国几乎延续了这一特点，只是偶见大器；当代串珠大小上日趋丰富，大小兼备。从检测上看，拍卖场上的串珠一般情况下也没有检测证书，其原因是串珠其实比较容易检测，有的时候目测一下就可以了，所以拍卖行鉴定时基本可以过滤掉伪的串珠。

酸枝手串

小叶紫檀珠

黄金木串珠

酸枝手串

仿花珀手串

小叶紫檀串珠

青金石串珠

鸡翅木串珠

金丝楠手串

八、典当行

典当行也是购买串珠的好去处，典当行的特点是对来货把关比较严格，一般都是死当的串珠作品才会被用来销售。下面我们具体来看下典当行串珠品质状况。

典当行串珠品质状况

名称	时代	品种	数量	品质	体积	检测	市场
串珠	高古	极少	极少	优／普	小	通常无	典当行
	明清	稀少	少见	优良	小器为主	通常无	
	民国	稀少	少见	优良	小器为主	通常无	
	当代	多	多	优／普	大小兼备	有／无	

唐三彩单珠与西周和田玉镯（三维复原色彩图）

金丝玉手串

银珠（三维复原色彩图）

金丝玉手串（三维复原色彩图）

金珠（三维复原色彩图）

由上可见，从时代上看，典当行的串珠古代和当代都有见。明清和民国时期的制品虽然不是很多，但也时常有见；主要以当代为多见。从品种上看，典当行串珠的各种种类可以说都有见，珊瑚串珠、黄花梨串珠、紫檀串珠、翡翠串珠、和田玉串珠、芙蓉石串珠、紫晶串珠、琥珀串珠、蜜蜡串珠、珍珠串珠等，一般的典当行有几十上百种的死当珠宝串珠很正常，但价值极低的不是典当行的范围。俗话

酸枝手串

酸枝手串

金珠（三维复原色彩图）

说就是一般都是值点钱的各种质地的串珠。我们在逛市场时应注意到这一点。从数量上看，古代串珠的数量在典当行极为少见；当代串珠在典当行比较常见，在总量上有一定的规模。从品质上看，典当行内的古代串珠以优质和普通者为常见；当代串珠由于数量比较大，所以在品质上也是参差不齐，优良和普通者都有见，但过于粗劣者典当行不见。从体积上看，古代串珠的体积一般都比较小，很少见到大器。典当行内的串珠在明清时期以小器为主，大器偶见；当代串珠大小各异，十分丰富。从检测上看，典当行内的串珠制品无论古代和当代真正有检测证书的也不多见，当代的串珠相对多一些。

芙蓉石手串

黄花梨串珠

第二节　评价格

一、市场参考价

串珠具有很高的保值和升值功能，不过串珠的价格与时代以及工艺关系密切。串珠在新石器时代就有见，如绿松石串珠、珊瑚串珠、玛瑙串珠、玉髓串珠、玉串珠、陶串珠、石串珠等都较为普遍。商周时期更为流行，秦汉以降，直至当代都非常流行。

从品种上看，串珠的品种呈现出的趋势很明显，是一个不断增加的过程，直至当代串珠，串珠的种类已由早期的陶串珠、骨串珠、牙串珠、金串珠、玉串珠等，增加到黄花梨、紫檀、红酸枝、瓷、沉香、沉香木、铜、角、竹、金刚菩提、核桃、猫眼、变石、变石猫眼、空晶石、矽线石、橄榄石、石榴石、镁铝榴石、铁铝榴石、锰铝榴

金刚菩提串珠

海蓝宝石单珠唐三彩碟组合（三维复原色彩图）

黄花梨串珠（三维复原色彩图）

石、钙铬榴石、钙铝榴石、翠榴石、黑榴石、钙铁榴石、水晶、月光石、蓝晶石、天青石、冰洲石、斧石、锡石、磷铝锂石、透视石、蓝柱石、磷铝钠石、赛黄晶、金丝楠、绿檀、黄金楠、猫眼紫檀、缅甸花梨、柯檀、翡翠、花奇楠、玫瑰金丝楠、非洲花梨、黑檀、桃木、血檀、朱砂、崖柏、红酸枝、和田玉、白欧泊、黑欧泊、火欧泊、玉髓、玛瑙、黄龙玉、蓝玉髓、绿玉髓、青金石、孔雀石、硅孔雀石、葡萄石、汉白玉、蓝田玉、菱锌矿、菱锰矿、虎睛石、鹰眼石、东陵石、水镁石、苏纪石、异极矿、云母、白云母、锂云母、针钠钙石、绿泥石、白云石、萤石、岫玉、独山玉、查罗石、钠长石玉、蔷薇辉石、阳起石、绿松石、鸡血石、田黄、青田石、水钙铝榴石、珍珠、珊瑚、琥珀、硅化木、龟甲、砗磲、煤精、象牙串珠等，可谓是品类众多。

在价格上自然也是参差不齐，相差甚远。有的串珠几十万元，有的则是几十元至几百元。不过，在整个串珠史当中主要是以质地为上。如珊瑚串珠中的阿卡价值最高，而一般的莫莫红珊瑚串珠价格就不是很高。另外，就是以时代为上。如西周时期焙烧红玛瑙串珠的价格如今达数十万元，而当代焙烧的红玛瑙串珠价格并不高。因此，串珠的价格总是受到各种因素的制约，而我们在市场上要注意这些因素。收藏到了高等级的沉香、珊瑚、玛瑙、翡翠串珠等，由于相当珍贵，价格可谓是一路所向披靡，青云直上九重天。

椰壳串珠

黑曜石串珠

　　下面我们来看一下串珠主要的价格。但是，这个价格只是一个参考价格，因为，本书的价格是已经抽象过的价格，是研究用的价格，实际上已经隐去了该行业的商业机密，如有雷同，纯属巧合，仅仅是给读者一个参考而已。

明 沉香串珠：380 万～ 480 万元。	当代 珊瑚串珠：0.6 万～ 10 万元。		
清 珊瑚顶珠：0.6 万～ 0.9 万元。	当代 珊瑚串珠链：0.8 万～ 1 万元。		
清 珊瑚串珠：2 万～ 3 万元。	当代 珊瑚、蜜蜡串珠：0.3 万～ 0.4 万元。		
清 象牙串珠：3 万～ 5 万元。	当代 珊瑚、花珀串珠：1.8 万～ 2.8 万元。		
清 琥珀串珠：0.9 万～ 30 万元。	当代 珊瑚、沉香串珠：0.6 万～ 0.8 万元。		
清 核雕串珠：0.3 万～ 0.6 万元。	当代 珊瑚、角雕串珠：2.8 万～ 3.8 万元。		
清 沉香串珠：20 万～ 30 万元。	当代 珊瑚、核雕松子串珠 0.6 万～ 0.8 万元。		
清 琥珀 108 粒佛珠：0.9 万～ 1 万元。	当代 珊瑚、犀角串珠：2 万～ 3 万元。		
当代 奇楠沉香串珠：300 万～ 500 万元。	当代 珊瑚项链：0.5 万～ 0.9 万元。		
当代 翡翠串珠：280 万～ 480 万元。	当代 珊瑚串珠：0.8 万～ 0.9 万元。		
当代 琥珀串珠：280 万～ 600 万元。	当代 珊瑚、青金石串珠：1 万～ 1.8 万元。		

酸枝手串

翡翠手串

红水晶串珠（三维复原色彩图）

酸枝串珠

二、砍价技巧

砍价是一种技巧，但并不是根本性的商业活动，它的目的就是与对方讨价还价，找到对自己最有利的因素。从根本上讲，砍价只是一种技巧，理论上只能将虚高的价格谈下来，但当接近成本时，显然是无法再实现砍价的。所以忽略串珠的时代及工艺水平来砍价，结果可能不会太理想。

通常，串珠的砍价主要有这几个方面。

一是品相。串珠在经历了岁月长河之后，大多数已经残缺不全，但一些好的串珠今日依然是可以完整保存，正如我们在博物馆里看到的串珠一样，熠熠生辉，光可鉴人。从实践中我们也可以看到古代串珠相当残破。当代串珠的品相主要是看其纯净程度、有无缺陷等，如果能够找到缺陷，显然对于砍价是非常有利的。

二是时代。串珠的时代特征对于串珠的价格影响是巨大的。因为早期串珠异常贵重，所以很多串珠都是往商周上靠，其实它们可能根本不到代，所以要仔细观察，如果找到时代上的瑕疵，则必将成为砍价的利器。

三是精致程度。串珠的精致程度是轮锤砸价的最理想的切入点。因为几乎所有材质的串珠都有精致、普通、粗糙之分，那么其价格自然也是根据等级参差不同，所以将自己要购买的串珠纳入相应的等级，这是砍价的基础。

总之，串珠的砍价技巧涉及时代、铸造、组配、质地、大小、净度等诸多方面，从中找出缺陷，必将成为砍价利器。

小叶紫檀手串

红酸枝手串

南红手串与碧玉灯
（三维复原色彩图）

小叶紫檀串珠

金丝玉手串

鸡翅木串珠

仿花珀手串

阿卡红珊瑚单珠与西周和田玉镯（三维复原图）

第三节　懂保养

一、清　洗

　　清洗是收藏到串珠之后很多人要进行的一项工作，目的就是要把串珠表面及其断裂面的灰土和污垢清除干净。但在清洗的过程当中首先要保护串珠不受到伤害。一般不采用直接入自来水的方式来进行清洗。因为自来水中的多种有害物质会使串珠表面受到伤害。通常是用纯净水或医用酒精清洗串珠，待到土蚀完全溶解后，再用棉球将其擦拭干净。遇到未除干净的污垢，可以用牛角刀进行试探性的剔除，如果还未洗净，请送交文物专业修复机构进行处理，千万不要强行剔除，以免划伤串珠。但同时要指出的是串珠的品类过于丰富，要注意具体问题具体分析，不同的材质要有不同的清洗预案的，如沉香串珠的清洗和水晶、玛瑙可能有很多不同。我们在保养时应注意分辨。

金丝楠串珠

翡翠带绿和田玉珠（三维复原色彩图）

二、修 复

串珠历经沧桑风雨，大多数需要修复，主要包括拼接和重新穿系两部分。拼接就是用黏合剂把破碎的串珠片重新黏合起来。拼接工作十分复杂，有时想把它们重新黏合起来也十分困难。一般情况下主要是根据共同点进行组合，如根据串珠的形状、纹饰、质地等特点，逐粒进行黏合，最后再进行调整。重新穿系只有在商业修复的情况下才进行，一般情况下拼接和重新穿系完成的只是考古修复，只有商业修复才能达到真正的完好无损。

蜜蜡串珠

小叶紫檀串珠

925 银链

蜜蜡串珠

黄晶珠（三维复原色彩图）

三、锈 蚀

　　古代串珠如果是金属串珠都会有不同程度的锈蚀，因为金属串珠与空气结合会起化学反应，锈蚀的严重程度和串珠所处的地区有着很重要的关系。一般来讲，天气干燥的地区，如我国的黄土高原地区，串珠的锈蚀程度要小一些；而南方如上海、江浙一带的串珠在锈蚀上就会严重一些。铜锈的色彩多呈现出绿色，这种锈蚀一般较稳定，全称为碱式碳酸铜，在串珠表面分布很广，一些串珠上布满了这种绿锈。一般情况下，我们不需要去除掉它，只有在影响到纹饰观赏时才将其去掉。

四、沁 色

　　历史时代的玉石类串珠由于保存的环境主要是墓葬和遗址，长年受到土壤、矿物质等的作用，产生了多种化学反应，在玉器之上留下了多种多样的沁色。这些沁色是岁月留痕的标志，同时也成为断代的重要依据。同时"玉有沁"也能反映出玉质的优劣，这一点很明确。如西周晚期虢国墓地出土的古玉器，玉质多数为和田青玉，容易形成沁色。但必须是和田优质玉才能形成沁色；如果是一块石头，即使将其浸泡到墨水里，出来之后也是"出淤泥而不染"，不会形成任何沁色。另外，石头在墓葬当中无论是多长时间，出来之后依然还是石头的颜色，这一点从新时期时代的石头之上可以得到很鲜明的证明。由上可见，沁色不必清除，因为它正是古代串珠的印证。

五、日常维护

　　串珠日常维护的第一步是进行测量，对串珠的长度、高度、厚度等有效数据进行测量。目的很明确，就是对串珠进行研究，以及防止被盗或是被调换。第二步是进行拍照，如正视图、俯视图和侧视图等，给串珠保留一个完整的影像资料。第三步是建卡，串珠收藏当中很多机构，如博物馆等，通常给串珠建立卡片，登记内容如名称，包括原来的名字和现在的名字，以及规范的名称；其次是年代，就是这件串珠的制造年代、考古学年代；还有质地、功能、工艺技法、形态特征等的详细文字描述。这样我们就完成了对古代串珠收藏最基本的工作。第四步是建账，机构收藏的串珠，如博物馆通常在测量、拍照、建卡片、包括绘图等完成以后，还需要入国家财产总登记账，和分类账两种，一式一份，不能复制。主要内容是将文物编号，有总登记号、名称、年代、质地、数量、尺寸、级别、完残程度、以及入藏日期等。总登记账要求有电子和纸质两种，是文物的基本账册。藏品分类账也是由总登记号、分类号、名称、年代、质地等组成，以备查阅。第五步是防止磕碰，串珠在保养时防止磕碰是一项很重要的工作，几乎所有的串珠都容易摔裂，运输需要独立包装，避免碰撞。

黄金木串珠

金沙石手串

黄金木串珠与玛瑙碟（三维复原色彩图）

六、相对温度

串珠的保养，室内温度很重要，特别是对于经过修复复原的串珠温度尤为重要。因为一般情况下如果是修复过的串珠，黏合剂都有其温度的最高限值，如果超出就很容易出现黏合不紧密的现象。一般库房温度应保持在 20 ～ 25 摄氏度。这个温度较为适宜，我们在保存时注意就可以了。

七、相对湿度

串珠在相对湿度上一般应保持在 50% 左右，如果相对湿度过大，串珠容易出问题，如生锈、生虫、失香等，对保存串珠不利。同时也不易过于干燥，如沉香串珠就不能过于干燥，否则其香味会受到很大的影响，因此保管时还应注意根据串珠的具体情况来适度调整相对湿度。

战国红玛瑙筒珠

金丝楠串珠

猫眼紫檀手串

第四节　市场趋势

一、价值判断

　　价值判断就是评价值，我们所作了很多的工作，就是要做到能够评判价值，在评判价值的过程中，也许一件串珠有很多的价值，但一般来讲我们要能够判断串珠的三大价值，即古串珠的研究价值、艺术价值、经济价值。当然，这三大价值是建立在诸多鉴定要点的基础之上的。研究价值主要是指在科研上的价值。古代串珠的研究价值很高，但艺术价值和材质并不一定是很好的。西周虢国墓出土的大量经过焙烧的红玛瑙在材质上十分普通，与我们当代南红玛瑙的品质相距甚远，但是由于其具有极高的研究价值，主要是作为重要玉礼器的组件，可以反映出西周时期人们生活的点点滴滴，因此具有很高的历史研究价值。这些都是研究价值的具体体现。总之，串珠在历史上名品荟萃，对于历史学、考古学、人类学、博物馆学、民族

珊瑚串珠

金串珠

蜜蜡串珠

学、文物学等诸多领域都有着重要的研究价值，日益成为人们关注的焦点。串珠的艺术价值就更为复杂，不同材质的串珠在造型艺术、纹饰、釉色、釉质、书法艺术等上给人的视觉体验不同，但相同的是不同时代的串珠都是同时期艺术水平和思想观念的体现。如沉香串珠、黄花梨串珠、金银串珠、碧玺串珠等精品更具有较高的艺术价值。而我们收藏的目的之一就是要挖掘这些艺术价值。另外，串珠在其研究价值和艺术价值的基础上，具有很高的经济价值。其研究价值、艺术价值、经济价值互为支撑，相辅相成，呈现出的是正比的关系：研究价值和艺术价值越高，经济价值就会越高；反之，经济价值则逐渐降低。另外，不同时代、不同材质的串珠还受到"物以稀为贵"、材质、做工、残缺等诸多要素的影响，品相越优，经济价值就高，反之则低。

玛瑙珠（三维复原色彩图）·西周

小叶紫檀串珠

二、保值与升值

中国古代串珠有着悠久的历史，历史上每个不同的时期流行的串珠有所不同。从收藏的历史来看，串珠是一种盛世的收藏品。在战争和动荡的年代，人们对于串珠的追求风愿会降低；在盛世，人们的收藏情结则会高涨，串珠会受到人们追捧，趋之若鹜。特别是质地优良的串珠，如高品质的沉香串珠、黄花梨串珠、南红串珠、和田玉串珠、翡翠串珠等，这些串珠既能佩戴又能升值。高品质的黄花梨串珠几乎都是一路上扬，还没有落过价。特别是近些年来股市低迷、楼市不稳有所加剧，越来越多的人把目光投向了串珠收藏市场，在这种背景之下，串珠与资本结缘，成为资本追逐的对象，高品质串珠的价格扶摇直上，升值数十至上百倍，而且这一趋势依然在迅猛发展。

从品质上看，人们对串珠品质的追求是永恒的。串珠并非都是精品力作，市场上各种品质的串珠都有见，但人们对于高品质串珠的追求是永恒的，选择精品串珠进行收藏几乎是唯一的选择，也正好契合了人们的各种美好风愿。因此，中国古代串珠具有很强的保值和升值功能。

黄花梨串珠

小叶紫檀手串

黑檀串珠

青金石串珠

小叶紫檀串珠

从数量上看，古代串珠已不可再生，特别是一些高品质的串珠，在数量上很少，如奇楠沉香串珠需要成百上千年才能形成材质，尤为难得。高品质的琥珀、蜜蜡也是这样，有的距今已经上亿年，可遇而不可求，串珠价格是扶摇直上。

从体积上看，对于串珠而言，本身的体积对于其价格的影响也是根本性的。特别是一些宝石类更是这样：如钻石串珠自然是单颗粒越大越好；又如橄榄石的串珠，其小碎石的串珠价格很低，但如果是大颗粒的珠子价格就完全不同了。另外，就是金器、珊瑚、琥珀、蜜蜡等串珠的价格基本上也是由其体积大小来决定，因此，在市场上销售这些商品时，基本上都是按重量来称重。

总之，人们对串珠趋之若鹜，串珠的消费量特别大，不断爆出天价，被各个国家收藏者所收藏，且又不可再生，所以"物以稀为贵"的局面也越发严重。串珠保值、升值的功能将会进一步增强。

参考文献

[1] 河南省文物考古研究所 . 河南禹州市瓦店龙山文化遗址 1997 年的发掘 [J]. 考古 ,2000(2).

[2] 青海省文物管理处 , 海南州民族博物馆 . 青海同德县宗日遗址发掘简报 [J]. 考古 ,1998(5).

[3] 浙江省文物考古研究所 , 海盐县博物馆 . 浙江海盐县龙潭港良渚文化墓地 [J]. 考古 ,2001(10).

[4] 湖南省文物考古研究所 , 永州市芝山区文物管理所 . 湖南永州市鹞子岭二号西汉墓 [J]. 考古 ,2001(4).

[5] 上海市文物管理委员会 . 上海市天钥桥路清代墓葬发掘简报 [J]. 文物 ,1990(4).

[6] 新疆文物考古研究所 . 新疆尉犁县营盘墓地 1999 年发掘简报 [J]. 考古 ,2002(6).

[7] 辽宁省文物考古研究所 , 本溪市博物馆 , 桓仁县文物管理所 . 辽宁桓仁县高丽墓子高句丽积石墓 [J].. 考古 ,1999(4).

[8] 广西文物工作队 , 合浦县博物馆 . 广西合浦县母猪岭东汉墓 [J]. 考古 ,1998(5).

[9] 中国社会科学院考古研究所洛阳唐城队 . 河南洛阳市中州路北东周墓葬的清理 [J]. 考古 ,2002(12).

[10] 广州市文物考古研究所 . 广州市横枝岗西汉墓的清理 [J]. 考古 ,2003(5).

[11] 南京市博物馆 , 雨花台区文管会 . 江苏南京市邓府山明佟卜年妻陈氏墓 [J]. 考古 ,1999(10).

[12] 淄博市博物馆 . 山东淄博市临淄区南马坊一号战国墓 [J]. 考古 ,1999(2).

[13] 广西壮族自治区文物工作队 , 合浦县博物馆 . 广西合浦县九只岭东汉墓 [J]. 考古 ,2003(10).

[14] 南京市博物馆 . 江苏南京市北郊郭家山东吴纪年墓 [J]. 考古 ,1998(8).

[15] 南京市博物馆 . 江苏南京市板仓村明墓的发掘 [J]. 考古 ,1999(10).

[16] 云南省文物考古研究所玉溪市文物管理所江川县文化局 . 云南江川县李家山古墓群第二次发掘 [J]. 考古 ,2001(12).

[17] 南京市博物馆 . 江苏南京市明黔国公沐昌祚、沐睿墓 [J]. 考古 ,1999(10).

[18] 河南省考古研究所 , 三门峡市文物队 . 三门峡虢国墓 [M]. 北京 : 文物出版社 ,1999.

[19] 苏东水 . 管理心理学 [M]. 上海 : 复旦大学出版社 ,1980.

[20] 郭大顺 . 牛河梁红山文化遗址与玉器精粹 [M]. 北京 : 文物出版社 ,1997.

[21] 湖北省文物考古研究所 . 湖北麻城市李家湾春秋楚墓 [J]. 考古 ,2000(5).

[22] 中国社会科学院考古研究所四川工作队 , 松潘县文物管理所 . 四川松潘县松林坡唐代墓葬的清理 [J]. 考古 ,1998(1).

[23] 内蒙古考古所 . 辽耶律羽之墓发掘简报 [J]. 文物 ,1996(3).

[24] 姚江波 . 中国古代玉器鉴定 [M]. 长沙 : 湖南美术出版社 ,2009.

[25] 苏州博物馆 . 苏州盘门清代墓葬发掘简报 [J]. 东南文化 ,2003(9).

[26] 姚江波 . 中国玉器收藏鉴赏全集 [M]. 长春 : 吉林出版集团 ,2008.